OUTER
SPACE
100 Poems

Edited by
MIDGE GOLDBERG

OUTER
SPACE
100 Poems

"**Ideal for dipping into**, and as easy to enjoy as a glimpse of the stars at night, this anthology is filled with those tiny doors into the infinite that poetry is so good at throwing open."

ROBERT CRAWFORD, Emeritus Professor of Modern Scottish Literature and Bishop Wardlaw Professor of Poetry, University of St Andrews; Editor of *Contemporary Poetry and Contemporary Science* (2006)

"**An eclectic collection** of poetry from BCE to the present, which reveals our unchanging response to a starry night, along with our changing understanding of the science."

JOCELYN BELL BURNELL, Professorial Fellow of Physics, University of Oxford

"**Like a ride in a spaceship,** this wonderful collection of poems takes you on a unique journey. Through a myriad of perspectives, you'll fly in space visit the stars and planets, and explore our place in the universe."

CADY COLEMAN, former NASA astronaut

Discover more at
Cambridge.org/outerspace

CAMBRIDGE
UNIVERSITY PRESS

D0200224

GRANTA

12 Addison Avenue, London W11 4QR | email: editorial@granta.com
To subscribe visit subscribe.granta.com, or call +44 (0)1371 851873

ISSUE 161: AUTUMN 2022

p.205 extract from *Schizophrene* by Bhanu Kapil reproduced by permission from Nightboat Books and the author.

This selection copyright © 2022 Granta Trust.

Granta, ISSN 173231 (USPS 508), is published four times a year by Granta Trust, 12 Addison Avenue, London W11 4QR, United Kingdom.

The US annual subscription price is $50. Airfreight and mailing in the USA by agent named World Container Inc., 150–15, 183rd Street, Jamaica, NY 11434, USA. Periodicals postage paid at Brooklyn, NY 11256.

US Postmaster: Send address changes to *Granta*, World Container Inc., 150–15, 183rd Street, Jamaica, NY 11434, USA.

Subscription records are maintained at *Granta*, c/o ESco Business Services Ltd, Wethersfield, Essex, CM7 4AY.

Air Business Ltd is acting as our mailing agent.

Granta is printed and bound in Italy by Legoprint. This magazine is printed on paper that fulfils the criteria for 'Paper for permanent document' according to ISO 9706 and the American Library Standard ANSI/NIZO Z39.48-1992 and has been certified by the Forest Stewardship Council (FSC). *Granta* is indexed in the American Humanities Index.

ISBN 978-1-909-889-51-4

MIX
Paper | Supporting responsible forestry
FSC® C023419
www.fsc.org

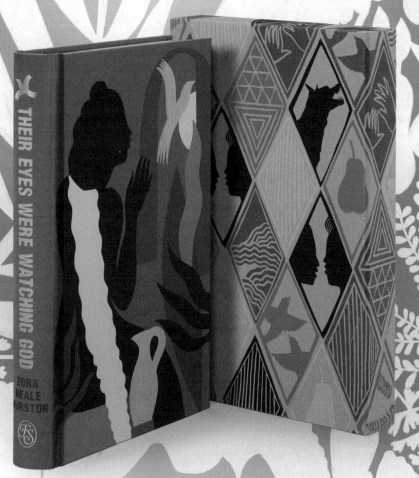

DEPARTMENT FOR CONTINUING EDUCATION

UNIVERSITY OF
OXFORD

Part-time courses in
Creative Writing and Literature

Short courses in Oxford and online
Day and weekend events, summer schools and weekly learning classes.

Part-time Oxford qualifications
Undergraduate and graduate programmes designed for adult learners.
Apply now for autumn 2023 entry

🐦 @OxfordConted **www.conted.ox.ac.uk/granta22-23**

CONTENTS

Introduction

W hat precisely is the sibling relationship, and how does it shape our lives? Cultures differ, of course, but if, from the point of view of evolution, partners survive by supporting each other, siblings survive by rejecting each other, and striking out on their own. But if resources are plentiful and the psychological stakes are not too high, they might play instead, until one grows up and rejects that magical space – and how disappointing it is to suddenly lose the mutual understanding of Sibspace (in Ben Pester's brilliant term).

John Niven's brother is in hospital, brain-dead, maybe dying. Niven vividly describes a scene where hospital staff refuse family access to brain scans on the grounds of 'patient confidentiality', as though his brother might miraculously return to life. To come up against ordinary hospital regulations at such a time seems a particularly cruel twist, but also, Niven wonders – what kind of miracle would it be? Perhaps we have forgotten that to wish for death – the end of suffering – is natural. Tolstoy's Levin, keeping vigil over his brother dying of consumption, feels the hypocrisy of pretending that a dying man could still live, and that the end was not longed for: 'They all knew he would die inevitably and soon, that he was already half dead. They all desired only one thing – that he die as soon as possible – yet, concealing it, they gave him medicine from vials, went looking for medicines and doctors, and deceived him, and themselves, and each other.'[1]

Emma Cline's obliquely profound memoir piece is titled after Goethe's poem *Erlkönig*, the Erl-King. She describes a walk – two sisters walking a baby, a seemingly ordinary scene that conceals the epic nature of this journey. In times of stress (Cline's sister had been gravely ill) anxiety can attach itself to remembered fragments of ghost stories and legends. The sisters are duly spooked; Cline remembers a childhood story, and so a great cultural arc comes into being, spanning from ancient fairy tales via Goethe's poem to a Disney record player and a memoir text for *Granta*. The stories drift in the wind; told and retold over the centuries.

[1] Leo Tolstoy *Anna Karenina* Penguin Classics (2006 edition), p.502, tr. Richard Pevear and Larissa Volokhonsky

An abundance of siblings can bring chaos. Viktoria Lloyd-Barlow writes with exquisite clarity about growing up in a household with numerous foster siblings, some gravely disturbed, and a tragically violent father. Lauren John Joseph describes growing up on an estate in Liverpool with a young mother who was like a sister, helping to care for numerous other siblings and half-siblings. A state of deprivation, in some ways, but also of tender chaos.

Swedish writer Karolina Ramqvist, by contrast, was a solitary child – until, that is, she discovered several sets of half-siblings. Here she describes the emotional legacy of her father's (and grandfather's) multiple affairs and marriages. Will Harris, on the other hand, was an only child who made up an imaginary brother, the theme of his forthcoming poetry collection – here he tells us why, alongside part of that poetry.

Sibling rivalry is a zero-sum game; a realm of eternal competition. Taiye Selasi's twin accused her of parasitic dominance in the womb. Suzanne Brøgger's sister broke with her after the publication of the novel *Crème Fraîche*, which solidified Brøgger's identity as a writer. Charlie Gilmour describes almost feral spats with his older stepbrother. Lauren Groff writes about a harsh end-of-winter ritual of competing with her siblings over who could endure the cold and sludgy water of the unheated pool the longest, timed by their doctor father. 'My memory tells me that I always won,' she writes. 'I would rather have died of hypothermia than let my siblings win.'

Groff was the middle child, the one who normally has to fight the hardest for space and recognition. A sibling combination is like a coded string of letters – BGG, in Groff's case, boy, girl, girl – each letter deriving symbolic meaning from its position in the code. In that sense, families remain forever feudal – those ancient ranks are hard to break.

Sibling feelings can turn on a dime, but for all the wonder at the lives of our siblings there is a part of us, I think, that sees it all – the slow transition from what we were to what we became – and understands the why and the how of it.

We get it. The degree of separation is only wafer-thin – maybe that's one of the compelling things about the state of sister/brotherhood. ■

Sigrid Rausing

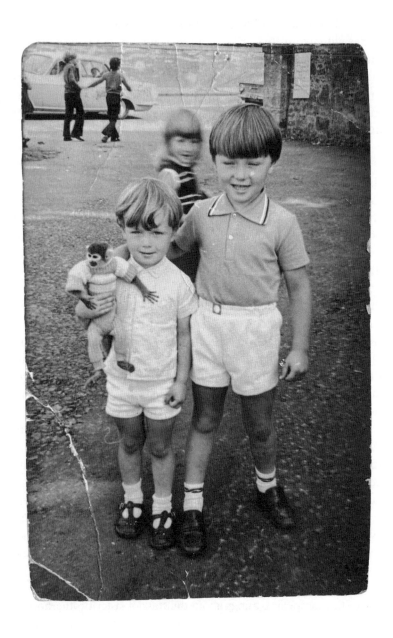

John Niven (right) and his brother Gary, Marymass Festival, Irvine, 1972
Courtesy of the author

O BROTHER

John Niven

Thursday 2 September 2010

I wake up early, just after dawn, back in my teenage bedroom at the age of forty-four. Well, I'm in a bigger version of it. The partition wall was knocked down a few years back, Mum returning the house to its original two-bedroom configuration. The strange, universal sense of depersonalisation it brings, waking up here. The peeling away of adulthood, of all you have accumulated since you left this room. All the plans you made in here, in the crucible of your adolescence. All the anxieties and insecurities you tried to work your way through. You can feel them gathering, the person you were then, trying to seep back into your bones. The curtains are thin and, at night, the orange street light seeps in, the same street light that lit the thousands of nights I spent hunched over the record player, the *NME*, the guitar, dreaming of being somewhere else, someone else. The bed, the room, the house, the town – they all feel much, much too small. I lie there thinking about the little warren of rooms around me, Linda still asleep in Mum's bed next door, Mum, up for a while now, shuffling around downstairs, making more coffee, turning on Radio 2. I am already wanting all of this to end, to move

on to the next phase: grief, mourning, whatever. I want to get in the
hire car and drive to Glasgow Airport. I want the attendant to bring
my Bloody Mary as we fly back to Heathrow, away from all this mess,
away from all the stuff that you can't leave behind. But we must go
back to the hospital.

So we go.

We meet the latest in a long line of doctors, this one a senior consultant,
who tells us that they have finally performed an MRI scan and that
the results are 'not very encouraging', but that we're going to 'wait
just a little bit longer'.

'Can we see the scan please?' I ask.

He hesitates. 'I don't know if that would help you.'

'Why not?'

'Well, would you even know what you're looking at, Mr Niven?'

'Of course not. You can explain it to me.'

'I don't think I can do that,' he says.

'Why not?'

'Umm, patient confidentiality,' he says, incredibly. And he's
reaching. There is almost a question mark left hanging in the air after
that 'confidentiality'.

And a voice in my head says – '*That's enough.*'

I take him lightly by the elbow and walk him a few paces away
from my mother and sister. 'The patient,' I say, nodding towards my
brother in the bed, my voice very quiet and calm (my voice icy, a bad
sign – in his diaries Alan Clark describes this as being 'just one step
away from bellowing with rage'), 'is unconscious and, as you just
implied, unlikely to ever regain consciousness.' I am speaking through
my gritted bottom teeth now, just like Dad when in fury. '*If* he does,
he's going to be severely brain-damaged. I want to know exactly
what's happened to Gary so we can explain it to my mum. I want
someone to show me the scan and walk me through exactly what he's
done to himself. Do you understand?' By the end of this little speech,
I am doing talking-to-a-child cadence. We face off. He's angry, this

guy. Unused to being spoken to like this. After a moment he says, 'I don't know if I can make that decision.'

'Then go and get the person who can.'

Another beat. He holds my gaze. 'Just a minute,' he says. And the modifying, Elmore Leonard-enraging adjective here would be 'curtly'.

He leaves. It's real, then. The growing feeling I've had since I got here of closing ranks and protecting flanks. Of people running scared.

A few minutes pass with the now utterly familiar sound: the steady hiss and click of the ventilator as it makes Gary's chest rise and fall, those pale blue coils on the monitor screens, the smell of disinfectant. The three-day stubble on Gary's face. His eyes still gummed shut. Mum is holding his hand again as she talks to him. Telling him about our night, about what we had for dinner, about when we got up that morning, about what went on with PopMaster.

The consultant finally returns. 'Mr Niven?'

'What the hell goes on in your bloody heid, Gary?'

I remember Dad asking this more than once, after whatever fresh outrage had been committed. Here it is, Dad. All laid out like a split cauliflower. We're in a small cubicle off the ICU. Up on the light box on the wall are the scans of Gary's brain, bone white standing out against smoked grey. The consultant's silver pen glides across the scans as he explains the clinical picture. Gary has effectively caused a monumental stroke. All the upper brain functions – memory, perception, motor skills, cognition – have been wiped out. Logic and reason are gone. (Again, and God help me, but how would we tell the difference?) So, there's no other way to ask it. 'Why are we keeping him alive?'

'Because we cannot say with total certainty that Gary is technically brain-dead.'

He explains that there might be a chance of Gary being able to breathe on his own if some of the brainstem's core functions are still intact. Based on his complete non-response to stimuli so far

this is unlikely, but the only way to properly find out would be to take him off the ventilator and see what happens. They will need our permission to do this and the consultant still wants to wait another twenty-four hours.

'What might change?' I ask.

He looks at me and says, 'You're a very inquisitive person.' This is not meant as a compliment.

I take a deep breath and say, 'As you might be, if your brother had walked into a hospital perfectly healthy and found himself a vegetable the next day.' *He was admitted into your care with suicidal ideation and was allowed to hang himself in a cubicle a few feet from a nurses' station. He came to you for help.*

'Yes,' he says, snapping the light box off, his own temper showing. 'But another way to look at it would be that if this had happened to him somewhere else and he wasn't already in a hospital then he'd definitely be dead.'

This certainly strikes me as what, a couple of years from now, will become known as 'a hot take'. I don't know what I can even begin to say in response, so I settle for my own curt 'Thank you for your time,' and go off to find my sister.

I take Linda outside, where I smoke, and we discuss how to break all this to Mum. Linda has a fifteen-month-old daughter at home. She needs to get back to Glasgow. We agree that after I tell Mum what the scan shows, I should, as gently as possible, try and steer her towards the idea of agreeing to turn the ventilator off, so that we can see if Gary can breathe on his own. We go back and collect her – she leaves Gary with a kiss on the forehead and the promise that she will 'see him later' – and I drop Linda at the train station, then drive us on down to the beach park.

You Were Being Good Boys

W e go for a walk along the harbour. The fine weather continues, and today might well be the most perfect so far. It's twenty-two degrees, the sunshine sparkling across the still water at the mouth of the River Irvine. The ancient, rusted blue crane is still here, the one that we used to dive off when we were boys, as Dad had before us. Across the river the sand dunes and seagrass stretch off past Bogside and on to Ardeer, to the munitions factory where Dad's fiancée died in that explosion nearly seventy years ago. And if that explosion hadn't happened then I wouldn't be here and neither would Gary and so on and so on. I look at Mum looking at the sea, and I wonder what she's remembering.

Back in the mid–late 1970s, during the long summer holidays, she would bring the three of us and our King Charles spaniel Candy down here nearly every day, a two-and-a-half-mile walk with a toddler in a pram, two small boys, a dog and the beach bag over her shoulder, crammed with towels and buckets and spades. Her tartan flask of coffee. The Tupperware box with ham and tomato sandwiches, the bread damp from the tomatoes, flecked with sand by the time we ate them. The walk would take us from our house along Elmbank Terrace, past the church and then by the shops on Caldon Road. Back then the newsagent's on Caldon Road sold toys and groceries, ham freshly sliced in the big, terrifying machine, sweets from huge glass jars. There was translucent yellow flypaper across the bottom half of the windows and in summer scores of dead flies and wasps lay at the bottom. One hot day, not long after we had moved to Livingstone Terrace – making me seven or eight, Gary five or six – we stood gazing longingly through that window at the Airfix models of Second World War aircraft while Mum was inside shopping. As we stared the shopkeeper's hands came into view and lifted two 1:72 scale models – a Spitfire and a Messerschmitt – out of the display. Some kid had just scored big, I remember thinking. When Mum came out of the shop,

she handed us the models. We hadn't even asked for them. We didn't have a lot of money and these were expensive gifts for us, the kind of thing usually reserved for birthdays or Christmas. I asked her why she had bought them for us.

'Because you were being good boys and hadn't asked for anything.'

I see Gary still, hugging Mum in gratitude, his arms wrapped around her legs in the sunshine on Caldon Road, his head nestling into her hip. It is one of those random memories of parental love and kindness that causes your heart to flex in your chest all these years later, a moment that you know will very likely be somewhere among your last thoughts. Is it somewhere among his now? Are there any thoughts left? Or are they all leaving him, swirling like a galaxy of stars circling a black hole and then vanishing, the memories of a lifetime crackling like the screen of an old television set, pinprick pixels disappearing into a white spot in the centre, then slowly fading away to nothing? Have they already left? Is his mind already a dead screen, the screen of the portable television after it toppled backwards to the bedroom floor, the tubes smashed, the circuit boards burned out, the glass cold to the touch, not even the Velcro crackle of the residue of electricity as you draw your hand across it? From the newsagent's we'd continue along Quarry Road past the playing fields, then across the high street and down East Road, past the pitch-and-putt course and across the river on the metal bridge at the Low Green, past the sawmill where our uncle Sid worked, past Fullarton Parish Church, where our parents had been married, and finally onto Montgomery Street, the last stretch towards the beach.

The newsagent's, the pitch and putt, the sawmill and Dad are all long gone as I sit with Mum in the warm sun on a bench overlooking the mouth of the river, the ghosts of childhood all around us: Gary and me running whooping into that water, Linda singing to herself as she filled and emptied her wee bucket with sand, as she patted at it with her spade, Candy whimpering in the shade of the windbreak, her golf-ball-sized eyes pleading in the heat, Mum slathered in Ambre Solaire, frowning into her fat Mills & Boon. She was in her

early thirties back then. Her husband had a good job and a car. Her children were all healthy. It was, I now understand, the happiest time of her life. The woman next to me is sixty-seven. Her husband is dead. Her youngest son is neither dead nor alive, floating in purgatory eight miles east of us.

'Mum, listen,' I say, taking her hand.

No one knows what no one said . . .

The night before, Linda and I sat up after Mum went to bed, making our way through a bottle of red and talking Gary.

'New Year was always a bad time for him,' Linda said. 'The one before Dad died, 1992, Mum and Dad were away, I'm still living at home, and I decided I was going to have a New Year's Eve party. Gary was in a flat at the time, nearby, around Martin Avenue? Anyway, he hears about the party, comes around to the house and says, "Naw, you're no doing that. The place could get wrecked." I tried to explain that it wouldn't be a big do, all our mutuals would be there – Peter Trodden, Tony Scott, David and Kevin, that kind of thing – but no sale. Gary is adamant I'm not having a party, and I'm nineteen at this point, so I'm like, "You're not the boss of me." He's in my face, screaming at me, shoving me, pushing his finger in my chest, and then he storms out the front door, he's walking across the street, heading back to his flat, and I shout after him "Wanker!" And I remember really clearly, he stops, turns around, and walks very slowly and deliberately back towards the house – I've no idea why I didn't just lock the front door – and he comes in, shoves me down in the kitchen and just starts battering my face on the floor. Then he leaves. I'm crying, a mess. But I phone a few of my pals and they're like "Fuck him", so we go ahead and have the party. Gary rings the house while it's going on, and I think Tony Scott answers and calms him down, tells him everything's fine. Later, Gary arrives. He rocks

up with these three girls – really rough, hard-looking girls that no one knew – and all of them are jellied out of their minds, just wrecked. One of them ends up sitting on that wee nest of side tables Mum had and just smashing them to bits.'

Linda sighed. Sipped her wine.

'You know, after all his shite about the house getting wrecked, the only trouble caused was by him and these lunatics he'd started to run around with.'

We sat with our glasses in the marmalade flicker of the living flame gas fire that replaced the coal-effect electric fire, which replaced the coal fire. These four walls we grew up within. Me on the sofa. Linda on the carpet in front of the TV, in almost exactly the spot a family argument had climaxed with Gary leaping up to go and saw at his wrists with the bread knife. That was over thirty years ago.

'The next year, 1993, the first New Year after Dad died, Mum went away to a hotel with Aunt Emily. Gary's back living at home and he decides *he's* going to have a party this time. I came around quite late on, and it's scary. I mean there's the Hutchinsons there, Jock, all that lot. I come in the house and see that the living room door's been smashed to pieces, like someone's taken an axe to it. I come down the hall, trying to find Gary, and see the kitchen window has a black bin bag taped over it. It's been smashed too. Then I see Gary in the corner of the kitchen, his face all cut to bits, bleeding. A big gash across his nose. Turns out he'd gone berserk and just smashed his head through the window. All his mates think it's hilarious. Me and my pals just wound up leaving.'

'It all got exponentially worse after Dad died, didn't it?'

'He'd start talking some nights about how he was going to go over to the golf course with a sleeping bag to spend the night with Dad, on the first hole, where we scattered his ashes, you know? I don't think he ever did it.'

'What was the other time? With the gun?'

'That was the *next* New Year, 1994. Mum's away again and my boyfriend Jim is staying over, so the two of us are sleeping in Mum

and Dad's bed. Well, obviously it's just Mum's bed at that point. I get woken up at four in the morning by Gary. He bursts in the bedroom and tells us, "Get the fuck out, I'm sleeping here."

"But Gary," I said, "there's two of us. This is the only double bed. You've got your own bedroom upstairs."

"Get out ma dad's fucking bed," he says. "I'm sleeping there." I remember he definitely said that – "*my dad's bed*". He said, "I'll give you ten minutes," and stormed off. We fell back asleep. The next thing I know, he's back in the room screaming "GET THE FUCK OUT! NOW!" I jump up and he's standing there pointing a gun at us.'

'Jesus.'

'I swear to God. I mean, I don't know if it's an air pistol or a real gun or whatever, but I start screaming "Okay! Okay Gary!" He leaves again and we're getting dressed and I decide to go downstairs and try and talk to him again. I get to the bottom of the stairs and he's coming out the living room door,' Linda points to the door just a few feet to my right. 'He's got a hammer in his hand. He comes towards me and brings it up over my head. I look at him, into his eyes, and they're just gone, he's on jellies, coke, whatever, and, for a second, I think – *he's going to kill me*. He looks that insane. And then I see this confusion coming across his face, like he's having a moment of thinking "What the fuck am I doing?" And he lets the hammer drop down by his side and he just starts crying and says, "Linda, I'm telling ye, jist get out of this hoose, now." I run upstairs, get Jim, and we end up walking round to his parents' place in the early hours of the morning on New Year's Day.'

1994. No longer the bright new dawn of ecstasy. It is the beginning of cocaine and temazepam sweeping Scotland's club scene.

For Gary, like many, it was all getting much darker.

There isn't a breath of wind as Mum cries softly, saying the same words over and over, '*Oh Gary, oh son.*'

I want to say, 'It's okay, it'll be all right,' the way she had to us, countless times, in childhood. But it wasn't okay. And it wasn't going

to be all right. Looking back through my notebook from that awful week, I see that I jotted down the following, just after I told Mum that the only thing keeping Gary alive was the ventilator, that he had destroyed his brain beyond all repair:

'A huge crow on a fence post near us, wings folded behind its back. Schoolmasterly. Its head clockworked around and I made eye contact. The crow as black, as Mum would say, as the Earl o' Hell's waistcoat.'

I once had a colleague in the music industry who was a keen student of the numerology of nature, of things like the tidings imparted by certain numbers of birds glimpsed together. I cannot recall any of his distinctions, but I am pretty sure that a single, staring black raven would not be among the good omens.

'No,' Mum says eventually. 'He wouldn't want that. He wouldn't want to be kept alive as a vegetable.'

She says this with a certainty I find surprising, having long given up on trying to figure out Gary's take on anything. Besides, over the next few days, a lot of things that Gary wouldn't have wanted to happen are going to go right ahead and happen anyway. 'Okay,' I say. 'We can talk to them about taking him off the ventilator.'

'What will that do?'

'He'll have to try and breathe on his own.'

I don't add that it's unlikely he'll be able to. And a voice that I am trying very hard not to listen to keeps saying, *'But what if he can?'*

Maximum carnage. Total chaos. The Gary Way.

All those thoughts come at me again – the slumped figure in the wheelchair, the eyes as empty as a politician's promises. The liquidised mush being spooned in, dribbling down his chin, his bib. Twenty or thirty years of that. And, if it came to it, I wonder, pursuing the macabre fantasy as far as it will go, who would take over after Mum died? It is difficult to know where the boundaries of love and duty are until you run up against them, but I know with certainty that I would not do this job. Linda, having much more in the way of the caring gene, would be a far better candidate, but I very much doubt that she would either. I picture Gary in his seventies, in the grim state

nursing home, his wheelchair parked in front of the fizzing television set, showing some game show that he cannot comprehend, the mind destroyed long ago, in that hot cubicle, the grizzled body somehow persisting.

'Will you talk to the doctors about it, son?'

Her eyes are flickering downwards as they fill again with tears, her hands fiddling in her lap, her jaw going. For a moment, she looks a seven-year-old who has been caught in something very bad.

'I already have. They want to wait another twenty-four hours.'

It is perhaps telling that Mum takes this not as betrayal, but as positive action. We walk the rest of the way to the beach, right to the end of the short stone causeway that juts out into the sea. The Isle of Arran lies straight across, the shoreline stretching away south to our left, down to Barassie, then Troon, then Ayr. To our right, to the north, lie Saltcoats, Seamill, Gourock, all these towns on the west coast of Scotland coming with their own evocations – *Arran; your stag night in 1992, Keith trying to throw your red Filas over the side of the ferry. Barassie; the Castlepark Primary School sponsored walk in '77, Mum packed you a lunch, a Mermaid soft drink in a plastic pouch. Troon; pub crawl when you were sixteen, after you'd worked clearing tables in the hospitality tent at the 1982 Open, where Tom Watson won his fourth and you saw Ronnie Corbett and Telly Savalas. Ayr; the UK Subs at the Pavilion. Saltcoats; drinking in Rudi's in '83 with Basil, the first time you tried Shlitz. Seamill; the freezing saltwater pool at the Hydro Hotel, where you learned to swim with the Boys' Brigade. Gourock; Primal Scream at the Bay Hotel in '86, Bobby's hands clasped behind his back, eyes closed, singing 'I Love You'* . . .

All this flies through me in two seconds, in the time it takes to scan the shore south to north. The memories that flow through you ceaselessly, like blood, until the day you die, or until you scramble them, wipe them like magnetic tape when you climb up on the stool, your head pounding, hot, tired and angry as you kick it away, and then that splinter in your brain soothed forever as the oxygen is cut off for two, three, four, six, ten minutes.

Friday 3 September 2010

We are gathered again in the family room of the ICU (the dust-furred plastic flowers, the pastel prints, the magazines: a royal in a tropical setting, a breakfast TV presenter's anthracite kitchen), and the doctor is explaining what will happen this morning. They are going to extubate Gary, removing the ventilator that has been filling his lungs for him for the last four days. He will then be breathing on his own. It is uncertain how long he will able to do this. It could be hours, minutes, days or months. Or perhaps indefinitely. (Linda and I exchange side-eye at this, the worst conceivable outcome.) The doctor suggests we go and get some coffee while they perform the process, and they will come and find us when they are finished. The three remaining members of the Niven family head for the cafeteria. The fine weather continues and the hospital, with its acres of glass, its heated wards, is stultifying, equatorial. We have just reached the counter and are ordering (Linda and I with our foamy flat whites, Mum's spartan cup of black filter coffee) when a nurse from the ICU comes running in and up to us. 'I'm sorry, you'd better come back right away. He started crashing the moment we removed the ventilator.'

Before we re-enter the ICU we are warned that he may be making unpleasant noises as he struggles to breathe. We are warned, but even so, my first thought as we come back in is – this can't be real. This isn't serious. Because Gary is making the worst, the loudest, snoring sounds imaginable: an asthmatic sea lion with a megaphone strapped over its mouth and nostrils. There is also the death rattle coming from his chest, like a bonfire crackling, like the pebbles of a beach cricking and shlocking as the tide rearranges them. It is horrific. Mum starts to cry. Gary is drowning from 'excessive respiratory secretion', common in extubated coma patients who cannot clear the fluid that quickly builds up in their lungs. There is also something called 'post-extubation stridor', giving rise to the impression – the illusion – that

the patient is struggling, fighting for life. Along with the shock of seeing someone who has been utterly silent for four days suddenly making all this noise, there is the shock of seeing his whole face again, unadorned by mask and tube. There are indents next to his mouth, livid purple bruising, like the stains from a night fuelled by red wine, at the right-hand corner of the lips where the ventilator tube has been resting.

And then there are the numbers and lines on the phalanx of monitors at the head of his bed, the blue of the foil on an Ice Breaker bar, Amstrad green, all tending the same way, spiralling downwards like a stock market crash. I stand at the foot of the bed. Linda sits on Gary's left side, head down, crying, shaking. Mum stands on his right and takes his hand. After a few minutes the hellish snoring subsides, becoming an occasional honk or rattle. His heart rate was in the nineties when we came in. It is already in the fifties. Mum strokes his hair and talks to him. Linda and I are losing a brother, but we are both parents now too, and I know as we look at Mum – bent over, her tears falling onto her son's face for the last time – that we are both imagining the same thing: watching one of our own children die. The moment is hyperreal. Too raw to be properly comprehended. It feels like a nightmare, like being forced to watch a horror film that cannot be turned off. Malcolm McDowell with the eye clamps in *A Clockwork Orange*. It feels like the very skin has been peeled from our eyeballs as we watch her kiss his hot, feverish face and hold his hand. For the second time in her life, she is having a conversation with someone taking their last breaths. This time, however, the dialogue is entirely one-sided. Mum is crying hard, little gasps and high-pitched squeaks are escaping her, but she gets it all out in the end.

She says, 'You were my beautiful wee boy, Gary.'

She says, 'I'll miss you so much. I'll think about you every day son.'

And she says, 'I love you,' over and over.

Look after the three of them hen, Dad had said, as he died.

Now the numbers are in the twenties, flashing and beeping, cockpit instruments in a terminal dive. (*'Terrain! Terrain! Pull up!*

Pull up!') Linda takes Gary's other hand and presses her face into it as she cries. I'm watching the scene as part of it, as a son and a brother, but there is also the writer. *Yeah, that shit.* He is not quite part of it, he knows that, once this is all over, he will go into the little bathroom down the hall, lock the door, take out his notebook, and record all these details, thinking that months or years in the future he will have need of them. And here they are now, more than a decade later, in the desk drawer in crabbed red ink (where did *that* pen come from?) in the black Moleskine. All the things that were said. The sounds he made, that Mum made. The wine-stain of that bruise.

I move around Linda and stand beside Gary, to the left of his head. The cut, bruised knuckles, the noughts-and-crosses board of scars on the forearms, contact points in my brother's long war against himself. I cradle his warm face: the scar across his nose, from the party Linda talked about the night before, the teenage act of lunacy when he was twenty-five. The broken vessels in his cheeks, blood forced up by the hanging. His right eyelid has flickered open a tiny bit and I can see the eyeball trying to flip upward in the socket, the pupil huge and black, fixed, pretty vacant (*Do you remember that? Sitting on the stairs all those years ago, where the echo was good? Me trying to play the Pistols on guitar? 'Load of pish,' you said. Is that still in there somewhere, even now, locked in a basement room somewhere in your memory palace as it all burns down around you?*). It is as if he is trying to look up into his own brain, into the organ that caused him so many problems: the splintering headaches, the crazy impulses and the bad decisions. I smooth the eyelid back down and lean in to kiss his forehead. '*Do you think I would leave you dying?*' Well, here we were. I put my mouth to Gary's ear and whisper – 'I'm sorry. I should have done more for you.'

His heart rate sinks into the teens, into single figures. The hellish snoring stops. The monitors flatline. Then, incredibly, one of the screens begins to rally, his heart rate heading back up again, into the twenties, the low thirties. I look over to one of the doctors who is

hanging back, a respectful distance across the room, my expression asking – is this a miracle? He shakes his head gently, telling me it is normal, it is the body doing its body thing, fighting to hold on to life. Another short, abrupt snore, shocking in its volume and suddenness. Electrical impulses, final signals. I lay a hand across his heart, my fingers splayed, where the spider legs of that monkey's fingers had once rested down the moors at the fair, a lifetime ago. *I'm sorry wee man – I can't get us out of this one.* In a voice that is not quite my own, high and breaking, I say my last words to my little brother: 'Come on Gary. That's enough now. Time to go, pal.'

With this benediction, Gary Alexander Niven dies.

It is four p.m. on a fine September day in 2010.

He is forty-two years old. ∎

MARK DORF
untitled9

THE DURHAMS

Ben Pester

I am in the Durhams' house now – it wasn't hard to find the place, even without my phone. It is a fashionable terraced house, not unlike the one I live in. Bigger, obviously. Much bigger, and in a grander architectural tradition. It has a front door the width of two front doors. Durham is older than me, he bought his house years before I bought mine, so he got a bigger one in a better area. I'm jealous of Durham's house. His walls have so much more surface than the walls in my house, there is more wall everywhere you look, and more floor. The furniture is enormous.

There are pictures around the place; family photographs blown up and mounted in specialist frames. Durham himself is in most of them, glaring out from under his grizzly brown fringe. His family gathered around. I examine each picture in turn, wondering about this man and his family. What were they like, the people who brought him into this world and share it with him? I have never heard Durham's mother's voice, for example. I will never hear it – she is dead. I look at her and try to imagine how she talked. Did she have an accent? What did Durham hear when she praised him, or chastised and mocked him, or consoled him when he was a boy? I cannot know.

I look at the pictures of his wife and son and try to imagine how they feel about being so closely associated with Durham. Do they

like him? They seem very happy. They must love him. I am glad. I am pleased to see Durham hasn't passed his ill-tempered face down to his kid. The boy seems unburdened in this picture here, even by the light of my torch, which tends to flash off the glass in the frame. I didn't want to come here at night. I actually had no intention of coming here at all. I have been resisting the urge for weeks. But then, in the middle of the night, I decided I had to.

I'm pleased to report that it doesn't stink here or anything. The Durhams took the bins out before they went away, they cleared most of the surfaces, but they left the fridge full of stuff. I'm looking in there now. Nothing unusual going on. Everything looks well preserved. I am actually impressed by the situation in the Durham fridge. Who keeps their fridge in such perfect order? I wonder. Is this a sign of their collective malfunctioning? Is this what called you here, if you have come here?

Running my torch over the kitchen peninsula, I see envelopes with names on. I see clean, dry piles of plates. A chopping board coloured pleasantly with years' worth of beetroot and mushroom dirt. It is wholesome rather than dirty. There are fruit flies on an orange half, the only thing out of place. They shift in the torchlight like iron filings taunted by a magnet.

Looking closer at the family pictures, Durham's son, who is older than my son, looks sweet, if somewhat obedient. He's smiling in a school uniform here. In this one; the uniform of the Cub Scouts. I feel bad about the boy. I don't want anything to happen to him. I hate to think he might actually be scarred by all this. I don't want anything to happen to any of them, not really, the Durhams. I'm climbing their stairs. The light from my torch shrinks as I climb into the darkness. The light becomes thin. I shine it around but instead of showing me bannisters and the expensive runner, there's just light coming back, like sunlight on a river. I keep walking up the stairs. Details clatter away. I can hear the sound of myself breathing. I can hear my voice, this voice, this voice if that's what it is. Doing this. These words and nothing else. As I reach the landing I catch my foot. I'm falling in

darkness. My spine shivers, bracing for impact. I try to detect a row of tents, or a flash of grass, something that will hold me still.

I am on the floor, but still falling. I feel my fingers touching surfaces I know to be furniture, but they slip away. Why have you come here, Benjamin? This question is on the air, cold as the leg of the occasional chair that the Durhams keep next to their massive bespoke bookshelf. I feel like screaming. I feel convinced that I am no longer alone. I continue to fall, and yet I remain on the landing of this tasteful, well-proportioned house. I am in the Durhams' house and I cannot leave.

Durham used to eat lunch with people, that was his thing. Anytime I was in the kitchen area, there would be Durham entertaining like we were not in a professional communal space, but a venue he had hired. Kebabs with the sales team. Health bowls with the developers. He was into the street food market near Old Street, and he would go with his chosen group every day. I never ate lunch with Durham. I could have done if I wanted, he was not exclusionary, but I liked sandwich and crisps. One time he was eating a soup and making everyone smell it. He beckoned to me, 'Come and smell this soup!'

I smiled, kind of thrilled by the prospect of how disgusting the soup was bound to smell. Then I realised he had not been beckoning me, but someone behind me – a woman I didn't know at all. I was forced to swerve away, down the staircase to the tenth floor where I remained hungry and unsatisfied for the rest of the day. Durham didn't notice, of course. He probably never meant to insult me.

Durham was his last name, but he never used anything else. Even his email signature, which I felt sure was autogenerated, just said Durham.

'People call me Durham,' I heard him say once to a swoggle of interns at a Thursday mixer. He said it like the severance of his first name (Dean) had been out of his hands. This bothered me. What was behind this need to be associated with the word Durham, and which Durham did he mean? The city? The county? The university maybe.

I didn't know which. All of them I suppose.

I left that company months ago, and I forgot about Durham and his lunches and his last name. But then I saw him one bright morning in the lobby at my current place. Here (though not here-here, because now, as these words come to me, I am in Durham's house).

'Wow, Dean!' I said. He was standing by the lifts with a dumb smile on his face.

'It's still just Durham.'

I nodded at this, apologised with a laugh. We stood in quiet for a moment, neither of us with anything worth saying. I couldn't even raise the energy to ask about his family. I felt more and more relaxed as I realised he was nervous about working here, in a place this enormous. His age seemed to rest heavier on him in this vast building. I was glad. I was glad too that in a place like this nobody could ever smell anyone else's soup. There are too many other soups that would get in the way. A society exists here that he could never hope to dominate.

I was thinking about his lunch obsession, and of all the many hundreds of chairs and tables there are in this office's canteen, and how I would basically never have to see him eating ever again if I didn't want to, when I said, 'We should catch up soon.'

He agreed, but we never set a date. I didn't think of Durham very much. I saw him from time to time. He gave muted waves. Nods of the head. We kept a respectful distance from each other; we had come to an understanding.

I say all this (Am I saying it? What is this that I am doing?) to demonstrate how little Durham meant to me. Nothing at all. Less, certainly, than the city or the county or the university – none of which I have ever visited.

He vanished from my life until one Thursday, when I saw him among a posse of lunch-people heading out through the lobby into the plaza. There he goes, I thought. He was near the back of the crowd, trying to keep up. He didn't even notice I was there as he passed by. I was thin air to him all over again. I felt a sense of relief

wash through me and went back to my lush, pressure-free sandwiches and my unimportant, boring work.

About a month after this sighting, I got the first email.

Subject: Sister

Hi Ben,
I need to talk to you urgently about a personal
matter. It's about your sister. My wife and I want to
meet with you outside work. Soonish if poss.
Durham

I didn't bother replying. I actually had a deadline for once, and I assumed Durham was trying to be funny. Or that possibly he was feeling lonely and was scrabbling for friendship – possibly after embarrassing himself at some post-work event. It felt like a stretch, but then the people here would not appreciate his smelly soup antics, I was sure. It felt like a vapid overfamiliarity that had no real weight. Maybe there was someone else the email was meant for. Ben Peston. Len Rester. Could've been either of those people, they both existed on the internal directory.

But a small part of me wondered. What if it was meant for me? What then? What did he want? The man knew I had a sister. It was one of the only things he knew about me – that my sister was an academic. He knew this because she had come to the old office once, having just returned from a conference in Durham. We were going to see our brother, Tom, and take him out on the town.

'This is my sister,' I'd told Durham. 'She's been in Durham.'

'I'm sure I would have noticed!' he'd said.

Even though we ignored this terrible joke, Durham insisted on leaving the office with us, walking us to the station. All the way he asked imbecilic questions about what the point of academia was, to the extent I had to apologise for his behaviour. We had to explain it all to Tom, who, of course, found it hilarious.

Maybe Durham's been drinking at lunchtime, I thought. Though it was still odd that he'd mention his wife.

I continued not to reply. I continued to be distracted.

Maybe my sister's said something controversial about wives, I thought. Maybe it triggered him. This was very possible – in the *Guardian* maybe. Or maybe she visited the University of Durham again and he was reprising his old joke. Or she'd ridiculed the city/university/county of Durham in some way, and he expected me to grasp the connection.

In any case, I put his email in the low-priority folder and pressed on with my work. Durham followed up a day later. This time by direct message.

> Hey mate! Really need to grab you for a sec, but can't get into the office atm. I'm remote working. Can you meet me?

> > Sorry Durham. I am super busy at the moment. TBH I never really speak to my sister. Not sure how I can help.

> FFS

> > Eh? Listen, I am really busy atm. Please just email me or whatever, but if it's anything about my family, I would prefer you to leave it alone. This is really not cool actually. I'd like it to end.

Was I shaken? Yes. But I remained outwardly calm. I put DO NOT DISTURB on the chat and took screenshots. I created a folder called 'Durham HR'.

I went back to my feebly progressing work. I thought about sending a text to Mum or Tom to see if they knew anything about the Durhams, but I didn't want to have to explain the whole thing so I left it.

Then another email came.

Subject: Invitation / check on your family

Hi there, this is Samantha, Durham's wife. He is typing this as I speak to him. I want you to know this because I want you to picture me standing here talking to you. Asking you as directly as I can to take this seriously.

I am urging you to please come and see us. Normally I would invite you to our home, but I can't. We are staying in a hotel outside of the city. We can't enter our house.

Your sister is there. She won't leave. I'm at my wits' end. She appears on the stairs. She howls and she makes noises like a crow and other beasts. I need you to help us. I think your sister has died and that she is haunting us.

The message went on to imply that the Durhams had not budgeted for any hotel stays. It was something they were unable to afford to continue doing, nights on end, at over £70 per room.

We're having to go down the corridor to see our boy. He's all alone at night. God knows what he can hear through the walls in this place.

I replied immediately, regretting being sucked into this nonsense even as I typed.

Maybe this is a joke. Maybe you've been hacked. Either way, since you have brought money into it, and children, I'll answer frankly. It's obviously impossible what you're saying. As far as I'm aware you've never met my sister. I'm not even prepared to concede to you that I have a sister. Durham (your husband) and I used to work at the same company and that's about the only contact

you have ever had with my family, or I with yours.

I'm clearly not going to agree to pay for your hotel bill. I have no suggestions for the collective psychosis you appear to be experiencing. You have my sympathy. I can recommend family counselling – this is not intended as an insult, I myself have been through family counselling, and couples therapy, and hypnosis. All of these things have beneficial qualities for social groups experiencing unusually high levels of stress. Or maybe you should take the money you're wasting on a hotel in the suburbs and go on an actual holiday.

If this was indeed a joke and I've somehow missed the point, I apologise. Work has been manic recently, and I'm not on my best form.

Either way, my best wishes to you all.

Ben

I was annoyed that I had replied, especially in a way that went along with the stupid things Durham was saying. It seemed clear to me that he had written that message, and his wife had no idea that he was using her name. He was having a breakdown. I wondered if I should talk to one of the mental health first-aiders about it, but I thought that my reply might implicate me, that I might have made things worse. I felt sure there was some training I'd taken, a quiz that had asked what I should do when faced with a crisis of this kind. I probably knew at the time of the training that the correct answer was not to berate the colleague in distress. I definitely would not have said that the best course of action was to play along with the delusion. As the afternoon wore on, and nothing came into my inbox – from the Durhams or from HR – I let the issue go and switched my attention back to the deadlines.

Only my denial at having seen my sister nagged at me. I had seen her (I had seen you). Only a couple of weeks ago you were in town for an hour, and we ate breakfast at a cafe near the station. We gave your dog a bowl of water.

'It's all she wants these days,' you told me.

'I feel the same way,' I said.

Your dog and I drank a lot of water that day, and I kept texting you later to say that I was in various different places asking to use the bathroom. I'm in the Guildhall School of Drama and I am asking to use the bathroom. I am in the London Transport Museum and I am asking directions to the facilities. I am in the Royal Academy with a high-end cake, hoping to go to the toilet soon.

I laughed quietly each time, as though you were there with me. Which of course you were, really. You were in the space we make for each other. I am aware that you are summoned by these messages I send you. It has been the same since we were children. We have this space and we have permission to summon each other into it. Sibspace. Though I've only started to call it Sibspace now, in later life. And only in my mind – I would hesitate to use that word out loud. It ruins it a bit. But that's what it is. I can send a message or phone you up and your voice, you, enters Sibspace and we give each other our time. Sibspace is so embarrassing. I can sense you wincing at it. What does it mean, Benjamin? It doesn't matter. We are close.

I felt ashamed for telling Durham we don't see one another any more. Alone in my kitchen in the dark I imagined you coming to the Durhams instead of to me. I wondered if you had tried to visit me in Sibspace and somehow ended up at the Durhams' house instead.

I tapped a message to you on my phone: Are you haunting the Durhams? Are you alive? I deleted it. I was too afraid of what the answer might be to send.

I tried calling your number but my phone made a strange robotic noise, which I remembered it making on past occasions when I had tried to call you and it turned out your phone was in a canal, or you had smashed it by accidentally dropping it down some stairs.

Alone in the kitchen, alone in my house, I wrote and deleted messages. Would you even receive them? I could not send them anyway. I was afraid of you not replying, or of someone else replying and telling me they were standing next to you, by the side of the road.

'She's not breathing,' they might reply. 'She's not moving at all.'

I watched a video instead, a recent talk you had given.

I watched you there, my sister, moving your arms behind the lectern. After about five minutes – only the introduction – I was completely lost. Your voice was a reassuring burr and crackle, giving knowledge to an unseen audience. Not entirely unseen, there were some heads. Hair and baldness. (All that scalp and hair covering those minds, and all of them listening to you. My God, I still reel from it.) I imagined my own head, seen from behind, a sort of hesitant tonsure. I nodded along to what you were saying. I felt an urgent need to stand up in the audience and say something absurd, or knock someone's hat off. I felt myself reaching out for a man in a hat. But the only hat would have been in a corridor somewhere, I guessed. Or in an office on a hook. I could feel a hook with a hat on it. A very precise form of communication: a hook with a hat on it. I watched you until the end of the video.

Then I called all the hospitals in London, one after another, asking if you or someone fitting your description had been brought in unconscious or comatose. I listened to the space while they went to check, while they looked at records and asked about bodies that had been rushed in through the emergency doors. Are any of these women comatose? Are any of them haunting a finance guy and his family? I had to wish then that they were all someone else's sisters. I had to wish someone else was in there and they were not you. I told the people who answered the phone that I prayed there was nobody else there at all. Empty hospitals, I said. I hope for row after row of unoccupied beds. They could hear that I was emotional, but they were busy, so the conversations were rarely satisfactory. Yes, lots of people hurt, and no, none of them are your sister. I called back each of them – can you go and check again – I sat in silence.

I crept towards the space I found in front of me, there in the silence. I pressed ahead while I waited for the hospital to check for your body. To see if it was there. I pressed towards a beige area, and there was a sound like the tearing open of a cracker box.

The fragrance also was of crackers – soft dust, grain, pressure, air. When we did not like the school dinners, these were the crackers they gave us, caked in white spread and liquid jam.

After some sensory adjustment, it felt natural to arrive at the reception area for a medium-sized campsite. It was a lodge, in fact. A reception lodge for a campsite. There was a desk with blocks of paper for guests to make notes. I touched some of the notes and the voice of the woman on the phone, the woman at the hospital, told me there was nothing and nobody matching the description I had given. I turned over the pages and the voice was gone. Had I said goodbye?

Durham started coming back to the office after a few days' absence. He would make excuses to come to my floor and hang around near the artworks. He'd not been looking after himself properly. He stank of mildew – of clothes taking too long to dry. His trousers were ruckled with creases. He clearly still considered me responsible for the situation he was in. I avoided his eye in every circumstance, even in the meetings he now seemed to attend, even though we worked on different projects. Nobody challenged his presence in these meetings. He just turned up. I couldn't stop him. It would've looked worse for me than him if I demanded he leave a meeting on a project, and it turned out he had a key role I didn't know about. I had to put up with him, and his stench.

I left the meetings before they were over, to keep away from him, but then Durham managed to corner me in the bathroom.

'Look what she's done now,' he said, and he demonstrated that his jaw had become massively elasticated. His lower jaw hung open like the cargo bay of a jumbo jet. Inside there his wet tongue dangled about, rubbery.

'Jesus,' I said. 'That's disgusting. See a doctor.'

'It's the ghost of your sister! She's cursed me!'

'This is absurd,' I told him. 'This isn't my sister's doing. Go see a doctor.'

I thought he was going to punch me. He was definitely thinking about it. I informed him that I was keeping a file about him and that I would be showing it to HR.

'How do you know it wasn't your sister?' he asked. 'Have you seen her recently?'

He lifted his jaw back into place before he spoke. It seemed stable but loosely articulated, like a child's swing. The effect was worsened by Durham's tendency to thrust his chin forward each time he challenged me with a question.

'No – my God I told you, I haven't been in touch with her for years. We keep our lives separate. I think we Zoomed at Christmas. But that was months ago, obviously. This has nothing to do with me. Leave her out of this,' I said.

'She might have died,' he said. 'And you wouldn't know.'

'She hasn't died,' I said, but my voice wavered. 'If she had died I would have been informed.'

'She might have been in an accident.'

'No.'

'But you haven't seen her.'

'I would have been told!' It annoyed me that I was raising my voice. What if someone heard us? I took a deep breath. Before Durham could start up again, we were interrupted by Simon, one of the developers I work with. He looked at us awkwardly as he went for a cubicle. I took the chance to leave the bathroom and escape to my desk.

I wrote and deleted several more texts to you. I wrote and deleted several more texts to Mum, and to Tom, our brother. What would he do in this situation? Something good and honest, and let's face it, with Tom this just wouldn't be happening. Durham would've just taken him for burgers and been happy. Everyone would have been happy.

I looked up your name on the internet to see if you had died. I tried to talk to you in my mind.

I saw Durham again later, at another meeting, his sad jaw swinging. Also, the skin under his eyes was drooping away from his eyeballs like warm putty. Was this supposed to be my fault too? My

family's? He kept smoothing the skin back into place and blinking rapidly. His ears were showing signs of running, an odd liquid like syrup trickling down his neck.

He left the meeting early, no longer interested, giving one word answers to complex technical product questions. He was broken. I stayed at the office as late as I could to avoid thinking of him in that state.

On my way home, I passed a hotel. I did not recognise it, but I felt certain it was the hotel that the Durhams were staying in. I looked at the square lights of the windows for a long time. I listened as the reception doors opened and closed, like the building was breathing.

I called you, but a boy answered.

'Who is this?'

'George Durham,' said the boy. He sounded morose.

I looked at my phone. I was sure I had tapped your name to make the call, but it just said Durham. I had called Durham's phone.

'I'm sorry,' I said. Then I hung up.

I tried calling you again, but this time I was connected to a hospital. I tried again and this time it was my work answering machine. I stayed on the line and listened to the sound of my office, empty and whirring.

I n the dark, in the kitchen, it grew late. The hospitals told me to stop calling. The police told me to stop wasting their time. I wrote and deleted more text messages.

I called what I thought was your number again, and this time I got through to an answering service.

I left a message. I explained that I was worried, and that we hadn't been in touch in a while, and that I had lost my way of contacting you. Something was wrong with my phone, I explained.

I said I wanted to go back to when we were kids, and Sibspace was just your bedroom door. I would knock on the bedroom door, and you'd have to turn off the music, and I would say something to try and make you laugh. And then I'd come in and try to make you laugh. And then I'd go, because inevitably I would just be taking up space, stopping you from doing what you wanted to do.

In the dark, in the kitchen, the beige area presented itself to me.

I moved towards the beige area. I progressed through the sensory alterations of the sweet reception lodge light. On the desk, a cork-ball key ring with a fluorescent ribbon rested near the desktop computer monitor. The key ring had a label that said Shed 1–5. I wondered if you were now represented here by the cork-ball key ring. It wouldn't surprise me. We have been in places like this, hungry for the campsite shop, wondering if we can play table tennis, trying to get things and to possess things.

I moved through Sibspace. There were empty chairs for waiting. The wood-framed glass door was set into a long window that overlooked the campsite.

I took this to mean you were not outside.

Through the window it was possible to see tents and cars, the white bellies of caravan roofs arched in the sun, swingball spikes with fresh tennis balls hanging slack, awaiting the bat.

I took this to mean you were not in the toilets or a cupboard.

I could hear the sound of tent-awning wind chimes ringing softly somewhere. I could hear a portable heater blowing dry heat at ankle height. This was the language of Sibspace, a burr in the throat.

I knew without having to travel anywhere that the reception lodge had toilets and to get to the toilets it would be necessary to pass the games room. In the Sibspace games room, of course, the games were not true games, but representational areas where amusing concepts we consider related to one another can gather and spend time. I became two unmoving table tennis bats and sought your attention.

Nothing changed. Not even the cloud in the sky which I could see through the games room skylight.

I moved through the air. I heard a voice but it was only our mother, who was a telephone table and chairs. She could not respond to anything I was saying, and I could not respond to anything she was saying. She was agreeing with the radio. She was agreeing that it is really jam-making that completes the scene of a contented allotment life. The dog concurred, I understood. You were not in the games room.

I felt our mother say, Of course she's not in the games room, but that sentence could have been related to anything. *The Archers*. Anything.

I visited the shop and I lay in wait as a multipack of small cereal boxes. I cried a great deal. I cried because you did not respond and I was worried then, as worried as a small box of Rice Krispies could be.

A horrible thought occurred to me. I wondered if Durham had been here. That lunch-boggling man in my reception lodge!

So I went outside of the lodge into the grassed camping areas. I moved slowly, and everything was slow. The air had caught in it the smell of warm car interiors. Where are you? I called, and my voice now took the form of barbecue smoke and confident familial discipline. A telling-off out of sight, an argument about boundaries in the surrounding fields. This was me begging for a sign that you had not died or been harmed or slipped in the bath.

Our brother Tom found me like this. He put his warm hands on my shoulders. He had been in a tent, he told me. An amazing tent with six individual rooms inside it.

'Holly is haunting the Durhams,' I said, and he laughed sweetly at the idea, and said how wonderful this was to be talking again after what had felt like a long time, and that I should try to be happier and feel lucky, because I was lucky.

'I'm sorry I didn't tell you,' I said, or tried to say out loud. 'I didn't want to make you worried or upset.'

I smiled somehow (I don't know how, some dust may have risen, not all of the required actions made sense beyond a physical sensation). I smiled at all of the things our brother was saying, and Tom sent the wind through the wild grasses in the casually swollen fields in order to reassure me, yet again, that my years of arrogance and bullying when we were children had been forgiven, he felt sure. Probably forgiven.

Night fell and I became cold on the lawn. Shapes that had once been bright motorhome windows became liquid, tents pooled and dissolved into darkness, the hills and grass failed, familiarity eked away and the reception lodge dwindled into nothing.

I am in Durham's house, falling into darkness, and I cannot hear you. I can hear only this voice (what even is this, this what I'm doing now?). I'm falling still, continuing to fall, and to speak to you here, in the dark. I remember almost nothing. I can hear only this voice, and I think that somewhere you may be dancing, and having a good time. ∎

Natalie Shapero

Nightstand

I keep picking up the book about trauma and recovery, but right
when I get to the end of section one, the door rings, the dog pukes,
the heater blows, fraud alert, tornado drill, get out
here fast, you gotta see this truck that ignored the height sign
on the underpass and now it's lodged like an overlarge pill
in the throat of the off-ramp, tangling the city where I poison
myself with the past, cough it up, cough it up –

PLASTIC MOTHERS

Lauren John Joseph

M y mother lay on her back in the water, pink amid mountains of foam, as steamed as a dumpling, dictating her thoughts to me. I was sat on the loo, taking notes with a biro, a secretary, a familiar, aware that elsewhere children my age were at their school desks studying Living Things and Their Habitats, glad I was not among them.

My mother said, 'Write this down, la.'

Beans Milk Bread.
Ask Grandad Jack to borrow twenty quid for the leccy.
Use catalogue money to pay Sandra.
Take hairdryer back to Boots for cash refund.
That should do us for the rest of the month, if we're careful.

She exhaled in satisfaction at having solved a problem more complicated than my Key Stage 2 algebra, and one with measurably greater real-world effects. 'An' put some waffles on for the kids, will you?' she added, sinking deeper into the bubbles, 'I'm going out in a bit an' I need a quiet half hour to get my head straight.'

For most of my childhood my mother treated me as confidant, as an accomplice in the many necessary and nefarious subterfuges

required to navigate around social workers, school teachers, debt collectors, and through the welfare system. It didn't ever seem unusual that as an eight-year-old I would be central to the discussion about whether to pay the phone bill or the gas bill that month, or that at eleven I would be out of school for weeks at a time, ostensibly to help my mother with the kids. I knew who not to answer the door to, how to fob off the milkman for another week, and exactly what to say to invasive case workers; you see, we shared the familial responsibilities, just as the Ribeiro kids from around the corner did whenever they were ditched by their parents for smack.

In essence she acted as though I were the kid her mother had left her to raise. She was my big sister, always frank, never embarrassed when discussing things your ma might be squeamish about – explaining sex and periods, sharing her mixed feelings towards Tony Blair, her desire for Marti Pellow. When her friends' dating advice proved subpar, she'd run over the pros and cons of Mark versus Richard with me; she really was willing to talk about almost anything. We would chew over women's rights, the IRA, Madonna – often while she was shaving her legs or waxing her bikini line – because more than anything she hated to be alone.

She was a teenager when she had me, a child cheated of childhood, daughter of a father who lived between the docks and the pub, and a mother who blamed her children for depriving her of the career she might've had. Her brother, my uncle, was violent, delinquent, abusive and left home to join the army, rather than face borstal. Her sister, my aunt, was chronically ill and spent her early life in a children's hospital six miles away, a distance my mother's mother walked daily, back and forth, the family being too brassic to afford the bus fare. She grew up with a family she didn't belong to but for whom she was responsible, some sort of indentured child servant. By the time she was thirteen she ran the family home, including shopping for groceries, cleaning, and cooking for her father when he rolled in drunk at eleven p.m. With this history you could say it was perfectly reasonable that she should ask me

to help her out, drop the kids off at nursery and go to the supermarket on the way back, miss a morning of school to wait in for the window cleaner while she went to have her hair done.

She was such a young mother, a very good-looking, vernal woman, so that strangers regularly read us as siblings, which flattered her deeply and made me feel incredibly grown up. I was the embarrassing little sister she was obliged to cart about, who might miss the finer details of the conversation, but who made up for it with charming and naive questions, with precocious takes of the, 'Well, as they always say on *The Sally Jessy Raphael Show* . . .' variety. Besides, all of her friends loved me – I was the youngest recruit to their girl gang and as such they would baby me, tell me how cute I looked, let me know that if I ever needed any advice I could always come to them. And, naturally, when one of the girls was in trouble I'd rush over with my big sister-mother and a bottle of Lambrini to comfort the poor wounded thing. We'd listen to Debbie or Sandra or Janet sob about a two-timing boyfriend, or the fella who'd robbed off with the Christmas jar, take her to A & E to get her face seen to, or help her pack his bags, call the social, share our condolences. My sister-mother would shake her head and sigh, 'Yeah well, they're all a bunch of bastards, aren't thee though?' We'd seen it all us two.

My mother was an inveterate collector of people, her numberless BFFs matched only by her endless fellas, and we often had a sozzled and sorrowful friend on our settee in need of succour, sometimes until very late at night. I remember her friend Lynn inconsolable in the living room screaming, 'He's been seeing 'er again! I'm gonna kill 'im, the bastard,' mascara smeared from brow to septum. She'd come over with a bottle of Smirnoff and a kitchen knife in her handbag, to ask us to take care of her girls if she went to prison. 'I've 'ad it this time,' she said, now stoic and focused, 'He's not gonna do this to me again.'

We were both shocked to see that she really meant to do it, really meant to kill him, and we spent the night scheming, coming up with

new distractions to keep her on the couch, such was the nature of those friendships. In the morning, when Lynn was sober and more reticent, my mother, my big sister, said I could take the day off school if I wanted to. 'An' if you take the kids in for me this mornin',' she smiled, 'then we'll go in to town later, do a bit of shoppin', an' we'll have our lunch out too.'

There was never really any compulsion to go to school. I think my mother sensed I was unhappy there, as she had been, and besides she liked to have company if the girls were busy with their own kids, or at the launderette. We'd go to the Debenhams cafe, or to Uncle Sam's Pizzeria where we'd share a calzone and a Knickerbocker Glory like two truants, bound up in complicity, sweating only slightly in the knowledge that the cheque we intended to pay with would bounce. I'm sure if she'd have been a smoker she would've bought my cigarettes, instead she was happy to flex the privilege of her majority and buy me the X-rated VHS cassette of Madonna's 'Justify My Love' from the second-hand record seller who wouldn't otherwise let me have it. She was the best. She went with me to get my nose pierced, and I went with her to get her first tattoo, a pink unicorn on her shoulder.

It was a reciprocal sorority, I was a good-natured little sister, so I repaid her favours. I would babysit for her when she had a hot date, bottle feeding my baby brother, separating my sisters who were forever brawling over the same damn dolly, waiting for the key to turn in the lock to see if the night had brought success or disappointment. If things had gone well I would discreetly take myself upstairs, leaving my mother and her date to smooch on the sofa to Wet Wet Wet. If things had gone badly I would make her a cup of tea and listen to her heartache. More often than not the kettle would go on come midnight.

She lost her own little sister in one particularly acrimonious love affair, when her fiancé, my brother's father, left her for my aunt. It was a stupendous loop the loop of logic, a betrayal as cruel as it was absurd; it transformed my mother into a rageful renegade, and my youngest sibling temporarily into both my half-brother and my

step-cousin, as his father migrated from stepdad to uncle, and then mercifully into obscurity.

The loss of my aunt, with whom she had been very close, compounded my mother's need to be the best big sister she could be to me. She let me drink at home with my friends, something no other mother at my unsparingly Catholic high school would've dreamed of, she covered for me when I skipped class, and if there were any suggestion that anyone had been unkind to me – on account of my, let's say, unusual comportment and self-presentation – she would also step up as my shit-kicking big brother. I always knew when she was really furious, because she'd start saying, 'No, I'm not 'avin' it. I'm not,' heading out the door perhaps on her way to decimate the staff at Kwik Fit, who had wolf-whistled and called me a little queer. She was something of a she-hulk in those moments. One morning I told her that my physics teacher had hit me with a textbook, the same afternoon she had him pinned against the wall, one glittering stiletto nail to his spasming trachea, with the deputy head beseeching her, 'Please! Mrs Hughes, ah, Mrs Sullivan, sorry, Mrs Bryan!' She was viciously capable of remunerating my hurts if not her own; she had been dealt such a cruel hand, and I was always aware of what it was she was trying to spare me from, namely the tyranny of men.

Undeniably she had bad luck with men, the worst. She dated con men, married men, gay men, she married alcoholics, wife beaters and child molesters, each leaving her with little more than another dent in her credit score, a black eye if she were unlucky, another baby if she were blessed. The alloyed stresses of inescapable poverty, devastating break-ups, and what seem obvious now as a series of mental health crises, took its toll. She very much fell out of love with life, for a while anyway, and started spending ever-expanding periods of time in bed, grieving a heartbreak, comfort eating crisps, unable or unwilling to parent, on account of all those lousy bastards she tried so hard to love.

Her melancholy was exacerbated by the death of her own mother when I was thirteen, it was the blow that laid her lowest, and it made

the needle jump from dejection to paralysis. She became a febrile ghost. She had seemingly strived all her life to make her mother love her, only to fail again and again. Each divorce was a greater disgrace to my grandmother, who was dogmatic in her conservative Catholicism even if she did only ever trouble the pews for weddings and christenings, referring, with mild derision, to God as ' 'im Upstairs'. Divorce was a great shame, abortion beyond contemplation, and when my grandmother died, my mother had not yet managed to prove herself reformed, of good standing, settled and married with any finality. I think that my mother only endured some of those men for as long as she did to spare my grandmother's further obloquy, to earn some affection through blind devotion, and she was devastated to realise that there was now no chance to make herself loved.

With fiancé, sister and mother all gone she simply surrendered to the duvet and sank beneath years of despondency, at one with her wretchedness. She could do almost nothing for herself, she ate only the toast I brought up to her, and only changed between nighties, from Winnie-the-Pooh to Minnie Mouse, when I came in to help her. I had barely entered my teens, yet she had become something like my baby girl. I even had to sleep next to her in the bed so that if she woke herself up crying, she wouldn't find herself alone. When she did drift off I was always relieved that she'd found some peace, and I had this misplaced parental pride that she always slept straight through. Nothing could rouse her, not my little brother calling from his cot through the night, not Janet from round the corner banging on the front door drunk and demanding that fifty quid back, not my sisters and me bouncing on the couch in her bras, monkeying the 'Justify My Love' video, tickled, seduced, ribald and ridiculous.

Today I can see this transposition as both an uncanny foreshadowing of how my mother would later take care of my sister's child, when she herself became psychotically depressed, and a bitter reminder of how my mother's mother had taken herself to bed for weeks at a time in rejection of the burden laid on her,

uninvited, as a parent. As a child, however, I was only aware that there were babies to dress, nappies to change, bottles to be sterilised, nurse's appointments to be made and toddlers to be dropped off at kindergarten. When I took my baby sisters out in their double buggy to the post office to cash the child benefit giro, or to Home Bargains for a twelve-pack of toilet roll, they were almost always presumed to be my own children. Where I grew up it wasn't unusual to see a fifteen-year-old hauling their baby to the supermarket, you see.

Mercifully, I have a sister, two years younger, with whom I shared the chit. We were so close in age and height and looks that we had nearly always presented as twins, another of our strange familial modulations, and we now became teen mums in our own right, almost overnight. We co-parented, as I had with my mother, divvying up the responsibilities. One of us did the kids' homework and the other went to parents' evening, one of us got up for the 2 a.m. bottle feed, the other took the baby downstairs at six. When someone needed to be dressed as Moominmamma for World Book Day, my proxy twin had to fabricate the costume; when my brother wasn't keeping on top of his homework his teachers held me responsible.

It was taxing, but I won't say that it wasn't also gratifying. We were both very proud of our domestic landscaping, and it always stung to see it trampled. Inevitably, unwanted father figures lumbered through this terrain, destroying, never helping. Our sister-mother's deadbeat boyfriends moving in, shacking up, shipping out, gifting us another baby, occasionally making wholly inappropriate advances towards other members of the family; we came of age like this.

My sister and I would sit up late at night wondering where our suddenly energised mother had run out to, with whom, and if it would require another change of name deed. I'd wash, she'd dry, we'd put the kids to bed, waiting up nervously for our maternal teenage daughter to come home. 'I really don't know what she sees in him,' I'd say of my mother's current mistake, and my sister would concur, most likely quoting Maury Povich or Ricki Lake, 'Yeah, well you have to let them make their own mistakes, don't you?'

For nights out, my sister-mother dressed from my pseudo twin's wardrobe; even into her forties she could still pass as my big sister. Sometimes when I came home at dawn, after sneaking out to those gay bars where I knew they wouldn't ask for ID, I'd meet her on the doorstep. She'd be searching through her handbag for her keys, heels in hand, eyeliner smeared, lipstick altogether faded. We didn't solicit details, just silently agreed to use the standard story on the off-chance my current stepdad had been sober enough to notice that either of us had been gone. It was an *I won't tell if you don't* stand-off; fear of violent men, like a borrowed halter-neck minidress, being among the greatest of equalisers.

The very last gradation of parental hierarchy was obliterated for good when my mother started dating one of my sister's friends, a man she knew from the job she had cleaning glasses in a pub through the summer she sat her GCSEs. My sister brought him to a barbecue in the back garden, my mother promptly offered him a glass of sangria, and that was that. Of course, she fell pregnant by this bloke, some twenty years her junior, and fought with my twin bitterly. Long drawn-out arguments that grew increasingly acrimonious until they spilled over into violence, the kind of bust-ups only sisters can ever really endure, open-handed slaps across the face, fistfuls of hair, the two of them wild as cats until I prised them apart. My sister was apoplectic that my mother had been so irresponsible, she was lit up with disgust and disappointment, screaming, 'Have you never heard of condoms?' and calling her a whore. It was pure inversion of maternal power, though myself I didn't have it in me to be so severe. Maybe I was also aware of how my stake in the game was different. I said that I understood – these things happen – and was grateful that we still had the baby bouncer in the loft.

I have often since wondered, if my mother's mother had've been slightly less repressive, would my teenage mother have aborted me, her first child, little sister, adopted parent? I sometimes think that would've been better for her, honestly, if for no other reason than she

wouldn't have been forced into a shotgun wedding, three months pregnant, with my otiose biological father. She had the grades, she was university material, she could've been the first one in the family to get a diploma. I think my grandmother would've forgiven her, eventually. I think she may have earned rather more love with an English degree and a teaching job than with eight kids and five troubled marriages, and maybe that's what happened, elsewhere in the multiverse.

Of course, my twin and I both begged my mother to keep the baby. I mean, what else would you expect from a pair of council estate brats, raised on TV chat-show propriety and misunderstood moral theology? I promised to drop out of school, said I'd quit my A levels and commit to life as a stay-at-home mum, while my sister swore blind she would never again speak to my mother if she terminated the pregnancy. The histrionics were at an all-time high that summer: recriminations, accusations and supplications triangulating between the three of us right up to the very last minute, when my sister, really still a child herself, worn down with pity, took our sister-mother to the clinic.

My mother didn't think it would be appropriate for me to accompany her to the clinic. She didn't spell it out but I understood, and though I know I would've been by far the more understanding companion, she decided that I should stay home instead. So, relegated by chromosomal differences to childcare, I waited, pacing the hallway sick with worry, sobbing, praying 'O Mother of Perpetual Help' while *Snoopy, Come Home!* wore on in the background. The children all knew something was wrong, they intuited it as little ones always do, they sulked and squawked and squabbled all day, and no amount of Disney or Petit Filous seemed to soothe them. My mother came home silent, my sister came back the more shaken up of the two. She didn't go in for her shift cleaning glasses that night; she said she couldn't face seeing her friend. Then she moved out, went to live with her boyfriend at his mum's house. My mother, being my mother, took over from her at the pub the next week, said it would do her

good to be out of the house. She was such a natural fit for the job, nobody seemed to notice or care, it's where she met her fifth husband in fact.

The two of them didn't speak for quite some time. How do you say sorry for splitting your daughter's lip with a punch? How do you apologise for telling your mother she's a slut? They'd crossed some indiscernible line and become abusive exes, though of course in a family as malleable as ours no role ever stayed fixed for long.

My sister was forced to call home eventually, by her boyfriend's mother, when she herself fell pregnant. Expecting to be berated, she was little short of thunderstruck when my mother told her, 'Yeah, me too.' Being pregnant at the same time, with baby number one and baby number eight respectively, made them drop their grudges like coins in the offertory, made them more like sisters than ever, the shared-joy bond of motherhood reforging a relationship that a year or so earlier had looked irreparable. And their children, being born only a couple of months apart, have grown up if not quite as siblings, then as some hybrid of cousin and aunt.

I would even say that my sister has taught my mother how to parent, which might well make her a grandparent, because with her own firstborn came the realisation that she hadn't really been mothered herself. She has always been very self-aware, and having identified a problem she works doggedly to rectify it, so out came the baby psychology books, the sensory toys and the *Classical Music for Newborns* CD. My mother watched with admiration, and adopted, if not the techniques, then at least some of the attitudes. She has come into her own in her fifties, parenting the youngest of my siblings in a far more boundaried manner, with unexpected patience. She is also an indulgent grandmother able now to treat children as children – she doesn't expect her tween granddaughters to cook or clean, and if she asks them to so much as pick up the wrappers from their Reese's Peanut Butter Cups they're flabbergasted.

M yself, I won't ever carry my own children, that's something which is sometimes hard to accept. I won't ever give birth, it's one mystery I cannot participate in, but that's okay, I've been a sister, and I've been a mother. I'm the eldest sibling, the proto brother-sister, the transfemme heir to the throne, in a family that also includes non-binary siblings and now, niblings. I think it is largely due to our amorphous and overlapping roles as sisters and daughters, parents and children, that my family has been so accepting of my own gender and sexuality, and indeed that of other members of the clan. We fully honour that which binds us together, love rather than genetics; we are not half-this or step-that, we are incorruptible siblings. We have felt the cold shoulder of upright society, have pressed right up against the limitations of the nuclear family, found it wanting, and have built an alternative for ourselves. We are a body of interchangeable parts, we are pro-choice; sister-brothers, brother-cousins, would-be twins, sister-mothers, daughter-grandmothers and cousin-aunts, every role plastic, every role learned and relearned. ■

Vanessa Onwuemezi (right) and her brother, Newquay, 1995
Courtesy of the author

BROTHER

Vanessa Onwuemezi

O nce as I stood next to my brother, he screamed my name. What is it to be named and have that name called out? Shaped by mouth and tongue of another. His body was small but the sound – back arched, eyes closed and knees bent so loud he called for me to come, felt my name stand tall with his voice and face to the sky and sound rung, rung my ears my bones shook. So loud, I would have come running towards the sound generated by this small body, back arched, knees bent under the weight of that sound.

'Sisa' was his first word, 'sister'. I had arrived here four years before him and had the knowledge of the world in his eyes. I allowed him to follow me around saying my name as it was then – 'Sisa', 'Sisa'. The word 'rivalry' naturally follows the word 'sibling', or some other mode of comparison: the firstborn and the last, the elder and the younger. And so we become individuals walled off from each other. But I feel porous in relation to my brother, in spite of being the 'elder', and more porous and related to the world as we get older.

One quiet morning I heard him shout 'Yes?' in his sleep, ripping through the still air, down the corridor, his eyes closed. He was hearing his name called from the outer edges of his psyche. A voice knitted into the slow-running stream where he floated between waking life

and that of his dreams. Even there he couldn't be left alone. And I was laughing from my room, most of the time I wouldn't let him cross the threshold and would watch him wait patiently outside. An assertion of my separateness, and at night the admission of the opposite as I slept in his room with him.

And how rarely this insistence on our separateness went both ways. How rarely he would bear a grudge. We had a fight over the remote control – which was really about my approaching puberty, my anxieties about my body, the future, my inadequacies, the world's unfairness as it felt to me, me, and for him? I don't know, but he was the first to apologise. He came to the room I had stormed into, the contours of his face wearing a maturity he was yet to grow into fully. As we hugged I was proud of him and in equal measure humiliated at my own loss of control, my shouting and screaming, swearing. He is never shy of hugs and kisses and I parse them out tentatively. He has a natural inner calm that for me was hard-won and he called for me to come, back arched his small body, knees bent and he screamed my name. Vanessa.

In a cafe in South Africa, the server notes my order under 'Sista', me being the only black person in the group. With a word he describes a shared experience that birthed a people. The parameters of my belonging expand like the universe is expanding into infinite space. I am related to people I don't know, might never know. I become 'Sista', and they, Sister-Brothers. It's useless talking about it, these things can only be felt and I feel like a body pinched off of some universal flesh. My body like all others, the meat bound by a thin outer skin concealing that focal harmony between us as kin of the world and it feels like your hard head under my chin, Brother, the smell of your shaved head and that curve of milk teeth that made up your smile.

I move in and out of the past as if from one dim room to another and can't say where a memory ends and my present self begins. Each memory folded in on itself ready to reopen, blooming into life and out again in a stream of perpetual deaths and rebirths, evoking the sad

transience of all we cannot recover. The time has passed, but we are still shaped by it. In a South African cafe I am reshaped by history by the word, 'Sista'. And there I recognised that you and I, Brother, are a microcosm of the relations between men and people and women, black to black and white and brown, any human relationship built up on the ground of intimacy – animosity is also intimate.

I could ask my parents to clarify what happened and when, and my brother if things went the way I think they did. But I don't care much about the facts. All past life is fiction. As playmates we were explorers, soldiers or doctors and dentists, or ourselves in peril or with superhuman powers. We froze Barbie in a block of ice so that we could chip her out. We made plastic bags into parachutes and threw dolls out of the window only to watch them smash on the ground below. We played for hours in the dark with glow sticks. We would answer the phone and pretend to be each other when the relative at the other end of the line would mistake your voice for mine and vice versa. I answer the questions meant for you, 'How's school?', 'Are you being good?', and neither of us would alert the caller to their mistake why? Because the daily details of our existence were trivial. School is good, yes, I am good, yes, there is happiness, yes there is pain today as with all days. And through becoming each other, we see that these aspects of us are not our Being, not us really.

My brother asked us to call him Michael, 'Only when we're doing DIY.' Now, it might seem funny and strange but a child knows the truth. With a new name you can alter your manifestation in the world. So we called him Michael whenever he was holding a hammer, and we related to each other anew at that moment. Just as in play we acted out the real truth seated within us. And played out the conflicts within us in acts of incredible cruelty, I poured baked beans onto my brother's head. I hit him on the head with a broom, he asked me to cut up an orange for him I pretended to cut off my thumb, I told him that there was a massive growth on my leg that he needed to cut out he shoved a stick down my throat while we played dentists. He shoved a toothbrush into my vagina as I climbed out of the bath. I hated holding

your head up as you slept in the car you locked me out in the garden with a rat, you killed my pet gerbil my love and those dolls we threw out of the window, the parachutes never worked and I love, I've missed this closeness as we've gotten older and I love, I love my brother.

But did I crush your dreams with my relentless piss-taking? I sometimes envied his talents, a quick wit and ability to make a room of people laugh. The envy, I expressed in ridicule and meanness, as on the threshold of my room I watched him wait. But the conflicts are always inner, in truth. At their base was my fear of losing: the closeness, a relationship through which I became myself and in which I am most at home in myself.

My dad sees his brother in the faces of men in the street. While his brother was alive and still now after he has passed. There is no real dividing line between life and death. The ones we love remain with us in our awareness. My brother moved abroad a few years ago and as soon as he left I began seeing him everywhere, young men seemed to take on his likeness and his absence became him, everywhere.

I was eight years old and speaking with him through a gap in the playground. Our playgrounds were separated, he being in another wing of the school. I watched him cry through this same gap a moment later, two red painted lines separating us which we children were forbidden to cross. He'd been told off for standing too close to it and I felt a pain that I wouldn't have felt had it been another boy there crying. Pain that rose from my own deep waters, as if I'd hurt myself, and simultaneously I'd rather it had been me. Just as a star is a dot in a vastness that is not empty, but filled with darkness, there are mysterious forces and processes that have created us and connect us: gravity, entropy, the bond of love or its other iteration, hatred. None of this my brother and I have expressed aloud to each other, but I feel it most keenly in his absence, reflected in the faces of all the young men that are not him.

Brother, to be your sister is to confront the possibility of having been other than I am. I'm not rehashing the debate about nature

and nurture. This is not about how I might have become more like one person or another, but how I can be a 'self' at all. To be named and have that name called out, back arched, knees bent he called for me to come and I am known as Vanessa, as 'myself'. Who would we have been had we been someone else? The answer is myself, always, 'myself'. The truth is that there is only one 'self' or to put it another way, all 'selves' are one.

To love my brother is to find existence in relation to another and he called for me to come, for what? I can't remember and there the memory ends or rather, dies to be reborn. ∎

My twin brother Elam and I were born prematurely in Hadassah Mount Scopus Hospital in Jerusalem. I weighed 800 grams, while my brother was a bit bigger at 1.2 kilos. Our parents named us Omer and Elam. In Hebrew, our names share the same first letter, ayin – ע – which also means eye. We were so small, palm-sized, that our parents went to a doll shop in Jerusalem to find clothes that would fit us.

The Torah passage we recited on our bar mitzvah, assigned by date of birth, was the shortest of the entire year – and we split it in half, like we did with the rest of the world. My brother's half of the world was centered on music, his love for classical and jazz. He drifted from piano to cello and finally settled on double bass – the largest stringed instrument in the entire orchestra. When he moved to New York City, he took the double bass from gig to gig, lugging it to Harlem, Jersey City, Bed-Stuy and the West Village, in snowstorms, under the glare of the summer sun, when leaves fell from the trees and carpeted the sidewalks, in the piss and chaos of subway stations. He carried the double bass around like a second person, another half.

For years, I was famous in my class for having the smallest handwriting. I loved drawing little things, imagining endlessly vast miniature worlds inside the hearts of trees, beneath layers of wood and bark, intricate clockwork interiors of screws and turning gears.

Now, my brother and I live two streets apart in New York City, and we always meet in the middle. Last week, we went to the udon place for lunch, and my brother brought his double bass because he was on his way to a gig. There was a sudden burst of summer rain, and we were caught under the tarp, slurping noodles from our bowls. A man in flip-flops and a Hawaiian shirt, hoping to escape the rain, hid under the tarp too. Looking at us for a moment, he asked: Are you brothers? We nodded. Twins? We nodded again, and went back to our food. When we were finished eating, my brother carried his double bass, heading downtown in the direction of his gig, while I went back to my tiny studio, to work on a novel about twins. ∎

WALES 2013–2022

Sebastián Bruno

Introduction by Sophie Mackintosh

W*ales 2013–22*, Sebastián Bruno's careful documentation of the communities of South Wales, is made up of images stark in their beauty. Cinematic and often verging on the dreamlike, the poses and situations depicted manage to be surreal, as much as the scenes are essentially quotidian. This surface-level ordinariness is misleading. I found myself returning to them, noticing a balletic sense of control, the small details – the angle of an arm, the expression of a young bride, a cross around her neck on a chain.

As I studied the photos one by one – a pale woman holding her child, a couple locked in an embrace, a street empty except for a woman, a billboard – I marvelled at how the stylistic choices give the environment of the photos a liminal and timeless feel, even as the title of the collection emphasises change, or a movement towards change. Nine years is a long time, and yet the photos do not outwardly reflect a great deal of visible change. Of course, much has happened in these last nine years. My mother, raised in South Wales, cried in 2016

when the Brexit result came in, knowing the impact it would have on the place she loved. These photos document the time before, the time during, the time after – not explicitly, but we know what lies underneath, even if it's not immediately what comes to mind.

The choice to shoot these images in a crisp black-and-white gives them a solemnity, a gravity. Sometimes even a sense of menace, just visible under the surface – in an image of several handprints pressed into wet concrete, both ghostly and frantic. Taken as a whole it can feel almost elegiac, the recording of a place as it is now and will not be again, though there is an aliveness in the images that makes this notion feel reductive. It's easy to write a place off; it's easier sometimes to mourn than to fight.

I was born in South Wales and lived there for the first few years of my life, and I go back several times a year to see my large and exuberant family, all of whom have stuck around, whereas my parents and I left. For a long time I have been returning, yet not quite of the place; knowing it, but not *knowing* it, a surface-level observer, passing through. My accent ebbs and wanes, depending on where I am, on who I am speaking to. But as I went through these images I vividly remembered walking around streets like the ones in the photos, houses like the ones in the photos, and I thought of the work of Martin Parr, another documenter of Valleys life. Though their styles are not so similar – Parr's photos are colourful, cheerful as postcards – with both there is a shared absorption in the details of the everyday. They share a curiosity with the small moments of life. Finding beauty in things which are not always the subject of art, and finding them worth recording.

Still, I am wary of romanticising too much – of gushing over *authenticity*, over realness, over dignity. But I do think it is important to think about what we allow to have glamour. What we allow to have drama, and not the kind of drama you look away from, the spectacle of a slapped face; but rather the sense that life, all around us and in the smallest moments, possesses power, and possesses beauty too. ∎

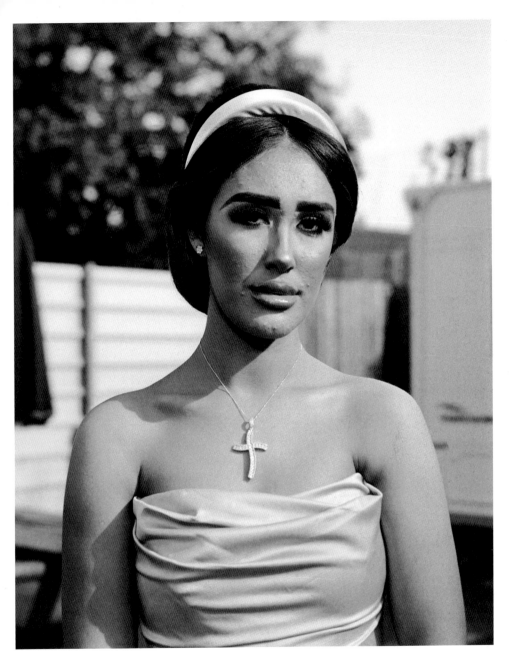

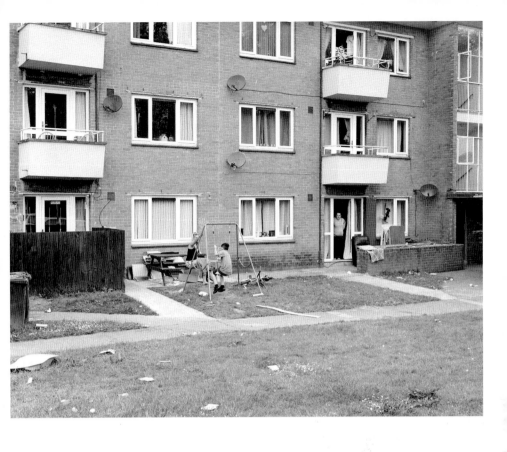

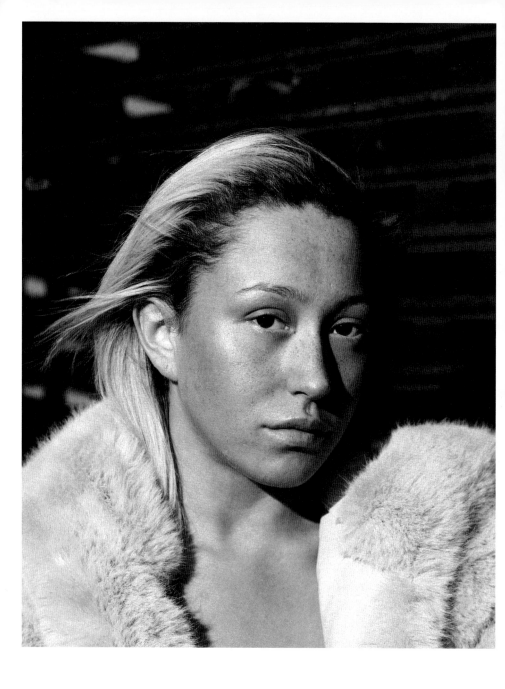

SCIENTISTS FIND CAUSE OF PREGNANCY KILLER

Pre-eclampsia cure hope

BRITISH scientists have found the cause of pregnancy killer pre-eclampsia, they said yesterday.

Ashes to ashes for smoking chimp, 52

Halifax Mortgages

£500 GIVE YOU
TO HELP KEEP YOU
WARM
THIS WINTER

MY BECKS IS A STUD

Terrorists in rocket hit on Brit diplomat

DESTROYED FOR LI...

Clem backs Green

After
sho...
Rob...
have...

TORY CONFERENCE

Blatter in vid U-turn

Battler Cameron vows:
We'll ALL feel the pinch

By TREVOR KAVANAGH

Swedish scientist Theodor Svedberg (1884–1971), grandfather of writer Karolina Ramqvist

SIBLINGS

Karolina Ramqvist

TRANSLATED FROM THE SWEDISH BY SASKIA VOGEL

'Nobody gets your family, Mum.' We're eating dinner in the kitchen, all five of us, and my son is responding to something I've just said about one of my best friends. He had asked if she was his aunt and I had said she was a friend, that she and I were not siblings. You know that, right? He shakes his head in pretend incomprehension, his little sister laughs and pulls the same face. No, Mum, nobody gets that. I look at my husband, who sits there quietly, his gaze drifting between the two of them. He looks at me. My eldest daughter puts down her cutlery. Her siblings are ten and eleven years old, she recently turned eighteen, darker hair, a different father. 'Another one,' as she would put it. She smiles. 'Listen up, little nuclear family kids, what aren't you getting?' She's expressing herself with my voice, a voice that could come from within me. She can hear what I hear when the younger children speak. Everyone who has grown up like them – with siblings, with a mother and a father – seems to want to note how far removed my family structure is to their own. Soon after people have asked me to explain, the message is always that they don't understand a thing. I don't know if I'm telling it badly or if it's really that complicated.

Unchallenged in her authority as the firstborn, my daughter leads her younger siblings in a roll call of relatives and friends. They

go through the names, determine the species of relationship and compare information. Then they grow bored and ask to leave the table, start talking about something else and get up before we have had a chance to respond. They crowd in front of the dishwasher, teasing and bickering over who should clear away what. Sometimes when they argue I hear myself hissing at them – How do you find the energy? – and every time it happens, they turn to me: We're siblings, Mum. It's just how it is.

Sometimes one of them will start a sentence with the words, 'we', and I've had to get accustomed to their *we*, a community that is so palpably ordinary and yet remains unreal to me. My own notion of a family was a single parent and an only child because that's how I grew up, in a Stockholm suburb in the late 70s and early 80s, and although I could conjure other images of how a life could be, this was the format rooted in me, the direction in which I, more or less unconsciously, was drawn. Family was me and my mother, and I assumed I would be a single mother, too – not live like this, in a real family.

An old-fashioned serving pantry leads from our kitchen to the living room. In one of the cupboards are some file boxes that I was given after my father died. I never open that cupboard, but I know they're there, three grey boxes with blank labels. You take care of them, the others had said. You, the writer. Maybe they understood that a writer could use whatever was in the boxes, or maybe they had seen how much I wanted them. It's been twelve years now. I took a quick look inside one of the boxes before I put them away, and I have yet to go through them properly – my father's life in paper form, left to my disposal. Over the years I have written four books, and I have written about my family in various ways, but I have never dared to venture into the story that I suspect is in those boxes. I pass the cupboard every day as I walk from the table where I write to the kitchen to make tea or fetch a glass of water, and sometimes I forget the boxes exist, but whenever I'm about to start writing a new book I think of them and wonder if perhaps the time has come.

M y father lived in another country when I was growing up. I only saw him occasionally, and sometimes years would go by without meeting. I missed having a father and wondered who he was. I collected the postcards he sent from his business trips around the world but dreaded his rare phone calls because I didn't know what to say to him. I was afraid of seeing him because I thought I'd disappoint him and wouldn't fit into his world, which was so distant from mine. The explicit story of my parents' separation was about class and culture. How impossible it would be for someone like my mother, an educated and hard-working woman from the most equal country in the world, to have children in England, where corporal punishment was still in use and children could be sent to boarding school from an early age. It was not something she could imagine for the two of us. When he settled in London, she moved us into a small rented flat in Stockholm. There was a playground, a primary and secondary school, and in the tower block next door an after-school centre, where children who had working mothers went to have a snack and play after school. Most of the children at the centre lived nearby but one day a new girl started. Her name was Klara, and her school was on the other side of the main road and the industrial estate beyond our building. What chance or circumstance led to her not getting a place at her local centre I can't remember, but I do remember how happy it made me because I understood straight away that she was going to be my friend. We were both in first grade and the same age – she had turned seven during the summer break, as I would later that fall – and there was something about her that I recognised. Her manner of speaking was familiar and her presence made me see that the other children lacked something which, until then, I hadn't realised that I missed. The two of us played every day, detectives or newspaper editors or scientists. She told me about her family and pointed out the house they lived in; she, her older sister and their parents. It was one of the yellow brick houses visible from our living-room window, and in the evenings I would look out at it, imagining them together in there.

All my friends had two parents and at least one sibling. When my mother had to work late or go to a party I might stay over with them, and although I was scared by all that came with siblings – uncrossable lines taped to the floor, crowding at the breakfast table and bathroom, fights over seemingly insignificant things – I envied them their families because they belonged together and were never alone, and because things seemed always to be happening in their homes. Our flat was quiet and empty, except when my mother's friends or colleagues visited. It rested in the stillness of my mother's work and my games, my papers and pencils and books.

I was aware that I had a brother, my father's eldest son, who was ten years older than me, and lived on the west coast. He and I didn't see each other often, but he was, to me, an ordinary half-brother. I can't recall ever being informed of his existence because he had always been there, and his mother, my father's first wife, sometimes sent us photos of him along with letters he'd written to me. When I was five a parcel arrived in the post with a stuffed toy and a note – *take care of him, will you, he needs to stay in the family* – and I remember the radiance of that word. Family, he and I.

Sometimes I tell the children that it was the same for my dad as it was for me. Or that it was worse for him. He too grew up missing one of his parents, and his was an even more complex familial structure than mine. I've said this to others too, to friends and acquaintances and people I barely know. I've said it to excuse my father for what he left behind, all this incomprehensible distance and emptiness, names and kinship careening through time and space, and I suppose it's also a kind of pre-emptive apology that I want to offer to my own children. It's unclear if they listen when I tell them, but I lay the padding down. I want there to be a softness inside them when they get older and start thinking about all this. If they ever will. I suppose it might be a positive sign if they don't. It might mean that what they have is enough, and most things seem to suggest this is the case. It was different for me. As a child I thought

about it constantly, my own loneliness set against all the relatives who were said to exist somewhere far away, living their lives without me and with no apparent longing for me, perhaps not even aware of my existence. I wasn't always quite sure that I did exist, and most of all I didn't understand why. I knew how babies were made, but it was strange that it could happen so easily, and I was surprised when my mother told me that I had been much longed-for, that my conception was something my father and she had planned together.

My mother didn't talk to me much about my father. She has said that she wanted to give me a chance to form my own opinions, untainted by hers – but she did tell me about his siblings, and about my grandfather. Was that her padding? Was she trying to prepare a muffled softness in me? Or did she talk about them the way I heard some of her friends do, pointing to a heritage that might tell me something about who I was? At that time, the early 1980s, nurture was still seen as the key determinant of identity, but people also talked about genetics and what could be inherited, such as intelligence, which my father's father and siblings had in abundance, and I thought I heard a kind of detached admiration in the adults' voices when the subject came up. My grandfather was said to have been a 'genius' – he exchanged letters with Einstein and Strindberg, became a professor of physical chemistry at the age of twenty-eight and was awarded the Nobel Prize at forty-two – but mostly I thought of him as a populator, the origin of all this. My father's family was a distant continent, bustling with alien beings, mostly nameless, some whose names I knew. They were architects, designers and scientists, and their professions and achievements were what defined them. One became a cellist, another had apparently been driven mad by intelligence. I imagined that it was his intellectual inheritance – the idea that it was possible to comprehend the infinity of the universe and all the laws of nature – that had driven him from reality. In our encyclopedia I read my grandfather's entry. I examined his portrait as I would examine my mother's photographs of my father. I remember the desolation that flared in me when I noticed that he had died five

years before I was born. Perhaps I'd thought that we'd met, that he had known I existed and had at some point held me in his arms and inspected my face. I must have had a notion of a relationship in a time before memories, because it was as if something collapsed within me when I saw the dates next to his name. 1884–1971. As for the rest of what was written there, I didn't understand a thing. Colloids, disperse systems and the analytical ultracentrifuge. I read it over and over, as if I could make it yield more, some explanation for the mystery of our family.

One evening, a couple of weeks into the autumn term of the year I met Klara, my mother went to a parents' meeting at the after-school centre. I sat waiting in the living room, and when she came back she said she had something to tell me. She started talking about Klara, saying that she had met her mother at the meeting and it turned out that they knew each other. Klara's mother had been married to my father before he and my mother got together – and Klara's sister, who was five years older than her, was also my sister. A half-sister, but still. I didn't only have a big brother, I had a big sister too. I remember the pounding in my chest as I walked to the window and looked out at the yellow brick house across the road. My mother stood behind me, looking out of the same window, and from what she'd said I understood that she'd known all along. I asked her why she hadn't told me I had a sister before, and she said she'd thought it was for my father to tell, since she was his child. Besides, she had been so sure that their family was still on the west coast. She had no idea they lived this close. She left it at that, and I didn't ask any more questions. I had so many, but it was as if they sort of slipped away from me, dissolving into the silence of the room and the view of the road and the industrial park and that wide dark sky above it all. My mother was still standing behind me, but I didn't turn. I stood there staring at the house, trying to reach inside and see my sister.

To the best of our knowledge, my grandfather had twelve children with four different women. There were four marriages, but other children could have been born out of wedlock too. Nowadays I rarely look in the encyclopedia, but on Wikipedia I see that my grandmother

was his third wife, and that we share a first name. When I was a child, my mother told me that I had been given my maternal grandmother's middle name. Did she not know that it also belonged to my paternal grandmother, or did she not think to tell me? Did my father know – and had he even been involved in naming me? The adults used to say that my grandmother was the only one of my grandfather's wives who lived like he did, with the same elastic sense of fidelity and coupledom – in one of the articles I read about him the writer called it 'norm-breaking' and 'modernistic'. My grandmother would hold court, they said, with various men, and had to leave the family when my father was two years old. They said she had been sent abroad, and of everything I have seen in those grey boxes it's the letters she sent to my father that I think of most, the letters and what she said to him when he sought her out as an adult.

Klara's parents invited my mother and I for dinner. I can't remember that night any more, but I'll never forget the afternoon the week before, when I left the after-school centre with Klara to meet her sister for the first time. Our sister. It's strange to think that we were younger then than my youngest daughter is now, because as I remember it I was a person with agency that day we crossed the road and walked to their house. A person whose life was about to change. I remember how Klara opened the front door. We stepped inside, hung up our coats and went to the kitchen, and there she was. She had the same name as my grandfather's first wife, who had been a doctor and advocated for sexual education and women's rights. I remember Andrea holding a bowl and whisking something, but when we talked about it recently she said that I was probably thinking of a different occasion, when all of this was still new. Our memories unravel and change shape inside us when we talk about them, regardless of whether they are shared or not. But however the details diverge, the three of us remember the most important thing in the same way – that this was when my sister and I met for the first time. I love Klara's description of it: how we walked into the kitchen and went up to Andrea, said a brief hello, and then went to Klara's

room as if nothing special had happened, as if everything was normal, even though we were electric with excitement and the knowledge that from this moment on, nothing would ever be the same again.

Their mother told me that I was part of their family and always welcome in their home. And the sensational thing was not only that I now had a sister, but that I had a sister like Andrea – someone that everybody would want to have in their life. In the years that followed, her loveliness became ever more apparent to me. I noticed that Klara and Andrea's mother had also done some padding, but in a different way to mine. They knew about things my father had done, and it made me ashamed when they mentioned them in passing, as if I already knew. He wasn't an academic success like his father, but he repeated his relationship patterns, the break-ups and betrayals, and I remember wondering if Andrea was so wonderful precisely because he'd abandoned her. I thought maybe she felt the same compulsion to be flawless that I felt but managed to achieve it better. Or was it revenge? Had she, by making herself perfect, got back at him for his absence – and if so, did such revenge have any effect? She had been even more completely abandoned than I was, but could claim Klara's father as her own, and I envied her that, just as I envied them for growing up together, as real sisters.

I was aware that Andrea knew our brother – their mothers had kept in touch and he looked her up once – but she never mentioned our father. I assumed she didn't want to hazard her pride or hurt her true family by taking an interest in him. Most of the time I didn't tell her when I met him or heard from him. He had a new wife in England and a place in the Stockholm archipelago to which I was sometimes invited, but meeting him was exhausting because he was basically a stranger to me. When I was fourteen he wrote to tell me that I had a new little sister. I stood in the hallway reading and rereading the letter, looking at the photo he'd enclosed. The baby was sitting on a bed with a white coverlet – she could sit up so she wasn't exactly newborn. He had never told me that I had a big sister, and now he had let months go by before telling me that I had another one. But

for the most part I was just happy about her. She was named after an ancient Norse goddess, and I thought her name might bind her to Sweden and to me. The following year he contacted me again and told me that his wife had given birth to a son who was to be named after our grandfather. Now I was an only child with four siblings, scattered here and there. Five, if you counted Klara, which I did. She was my friend but became more like a sister as I began to realise that we would always have each other, just as I would always have Andrea.

My brother was a self-evident part of my father's life, but not even he could get our father to approach Andrea. Did he know that they spent time together, that she and I had found each other? I think I told him as much once, a short sentence that I immediately regretted, and once after I'd met him in London I gave her his phone number. It had been our best meeting ever, and maybe we got the idea that something similar could be possible for her, but when she called him he said, 'Are you calling to blame me for what happened?' The same words his own mother used, when he called her after not having known her for the majority of his life.

In the final years of his life, my father moved back to the Swedish west coast. He met my daughter and my husband and introduced me to his girlfriends, friends, neighbours and acquaintances. I began to exist in his life a little, and it was as if, in the process, I became more real to myself. But he never approached Andrea. I suppose what I felt at the funeral, walking over with her to our younger siblings, was similar to what Klara had felt when Andrea and I first met, and I noticed that their mother could see how much she resembled our father. As we stood by the coffin, she held my hand as I cried and wondered what, of all things, I mourned the most. Many people had probably expected to see three children there, those who knew me would have expected four, but few people knew that our father had five children, and no one would have expected all of us to be there. Afterwards the youngest ones cried as we gathered to hear the reading of the will, and I saw that their tears were different to mine, partly because they were so young, but mostly because he actually was their father. In their faces I saw the

loss of the true father he had been to them. I'd always thought that one day he would compensate Andrea and me for his absence, with an explanation or something else, but when neither of us was mentioned by name in the will, I realised that it was the other three he wanted to compensate, because they'd had him. I imagined he thought we were lucky to have escaped him. He knew that Andrea had another father, and maybe he thought the man my mother married had also become like a father to me. That's how I interpreted his will. I don't know if it was just a way of staving off disappointment, or if there was anything to that psychological interpretation, but the sentiment was soft and forgiving, and I'm guessing it was the only one I could stand.

We all spent a few days together at our father's house, dividing his possessions up between us even though it wasn't what he had intended. Andrea showed me the newspaper clippings about my books that she'd found in his study, and I was given the file boxes and everything else I wanted. Now that they're in my cupboard, they're like a black hole around which thoughts about writing gravitate. Every time I've contemplated taking them down and getting started I've come to the conclusion that it is not yet time. The question is if anything is different now. I know that the longer I wait, the harder it will be to make sense of what is there. When I discussed it with my publisher once, she asked if there was anyone who had the whole picture, but I don't think my father ever fully revealed himself to any one person. I think he divided himself up, just as he divided up his life and his children. I shy away from talking to the people who knew him better than I did. I don't know what I am most afraid of – the act of approaching them, or of having his actions explained – or of finding that there is no explanation at all. That it really might be the case that things simply turn out the way they do, and that the story I've always imagined isn't particularly special after all.

For the child: not special enough to explain any part of her existence.

For the adult: not special enough to write.

W hen I look at my paternal grandfather's portrait now, I see how young he is, and how much he resembles all of us. I read about the things named after him – the unit for sedimentation coefficients, a lunar crater in 2009. I think about space–time, and the distances that multiplied between those of us who came after him, and how they shrank when we were nonetheless drawn towards each other, like the microparticles he studied. His biographical section on Wikipedia ends with my own name. It has been there for years now, and yet it still shocks me when I see it on the screen, that I have written myself into his story, worked my way alongside the other names.

Andrea once ended up on a tour of one of Sweden's great seats of learning, in the division of the department of physics and astronomy that bears his name, and afterwards she described how the guide had spoken of his affairs with female PhD students and undergraduates. The guide used a vulgar formulation, and there she was, silent living proof of this man's famous urges. I thought again of the fatefulness of desire and the randomness of family ties. I have wondered if it is for my children's sake that I want to write about this, to place myself and them in this story. Is that the very reason I write at all? Was it my grandfather's famous brilliance that made me think I could be a writer when I was small, even though the most renowned writers were other brilliant men?

After the funeral my younger siblings' mother told me that she had tried to talk to my father about me when I was little, saying that you couldn't just send for a child whenever you felt like it. The revelation that I had been part of their conversations was dizzying. Then she turned to me and Andrea and said there was only one thing we could do. I listened. All you can do, she said, is be there for your own children. It was such a simple notion that it made me want to cry. My son wasn't more than a month old and his little sister was so far only a thought. And now I'm not the only one around. My children's lives are populated, just like their home. What they are trying to grasp by listing all those names is not a distant unknown, but something close. It is not loneliness they want to understand, but how all the people around them, near and far, fit together. ∎

The year Gina went missing, we lived a block from the lake. We were twelve and thirteen and smoking cigarettes in our basement with friends – Mom and Dad at work, Hall & Oates on forty-five. We practiced strangling ourselves, that 'fun' game in which the bravest of us held our breath and squeezed our necks with our own hands until we passed out. The last time I did it, I woke up on the floor; they all stood above me, bent double laughing. 'You were flopping like a whale. It was hilarious.' We had just finished seventh grade and hadn't learned yet how quickly one wrong move escalated to the next.

Later, we played chicken by dropping cigarettes on our forearms. I'd breathe in slowly, turn my skin to slate, close my eyes and count: one one thousand, two one thousand, three one thousand. I could hold it longer than some of the others, but never as long as Gina who practiced pushing her limits. Gina, ten months older than me, made up new games with pocketknives. First it was just small notches on skin, but soon we began carving into our bodies – our tender flesh – the names of boy crushes, Luther, Michael, Carlos. By luck, I liked a boy named Jim. Only three letters. They were small letters too, smaller than my pinky, but I underlined them just in case anyone questioned my resolve. One of the girls got wasted and etched Scott or Sammy or Steve into the full length of her forearm so deep that the name survived long after the relationship faded.

Once, when we got bored with cigarette-chicken and pocketknives, Gina scored a joint from a senior near the gas station. We hid it in our bubblegum rompers and walked to the beach where the partiers hung out. She showed me how to grip the roach clip so I wouldn't burn my fingers, how to inhale the smoke straight through to the bottom of my lungs and hold it as if I were underwater. Later, she amped it up with Rush, those little vials of liquid speed that sent us soaring. We'd lean back into the couch and inch our way toward oblivion.

By March, just before Gina went missing, we were sneaking out at night by climbing down the tree outside our window. We'd walk up

Lake Avenue near the beach, where the biker bars and dance clubs blared 'Raspberry Beret' and Foreigner's 'Rev on the Red Line'. We'd pucker red lips and hike our skirts as we neared the lot where racers showed off tricked-out Camaros and fire-decaled Novas. The men drank whiskey from flasks and offered us rides. We took those rides – still so brave – but always according to a set of rules: never get sloppy, never get into a windowless van, never get into a car where the men outnumbered the girls, never go it alone.

But one by one we broke those rules. We'd pass flasks and joints in a car full of bearded strangers. We'd drive down the lake to a beach in a grove of trees where others sat on rocks, poured vodka over soda, snorted nitrous oxide, poked sticks into hot flames crackling late into the night. Sometimes New Edition's 'Candy Girl' was in the background, other times it was Chaka Khan's 'Ain't Nobody'. Each time we'd sit on laps, or allow hands on legs, and each time they'd pull us in just a little closer.

One day, Gina went out alone to the store or to the beach or to a friend's. When she wasn't back by morning, Mom and Dad called the police. The policeman took the report in our kitchen. He asked if there was a recent picture. I ran upstairs and rummaged through boxes, looking for the makeshift family album I'd made out of a lined notebook. I found a Polaroid that Dad had taken of the three of us on the back porch. Mom in the middle with a flowered polyester shirt, me on the left with a three-quarter length jersey tee. Gina on the right wearing a red button-down number with a white belt. She was like Little Red Riding Hood, her forest the parking lot by the beach. She had a way of looking sultry with her superstar smile, all white teeth and square jawline. Her eyes dreamy slits.

I wouldn't understand the weight of what happened until long after Gina came back, a different girl, and told us about that pimp who'd

picked her up, not until after we had gone through all those years of shelters and foster homes, after the chaos and fights and each of us running away again and again, wouldn't understand it until long after the detention homes, the jails and the psych wards.

But that morning when the policeman took the report I was still young and hopeful, and I assumed that things would work out. I peeled the photo from the page and ran downstairs with it. The officer promised to bring it back after he had made copies. He asked if there had been any strange behavior or fights, anything out of the ordinary. No, we said. No and No. Everything is the same as it's always been. ∎

THE MAKING OF THE BABIES

Lee Lai

YOU KNOW, I'VE BEEN WAITING TO BE IN THE SAME ROOM AS YOU TO SAY IT—

YOU WERE RIGHT.

THANK YOU! I WAS!

YOU DON'T KNOW WHAT I'M ABOUT TO SAY, YOU LITTLE SHIT.

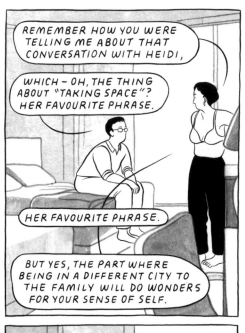

REMEMBER HOW YOU WERE TELLING ME ABOUT THAT CONVERSATION WITH HEIDI,

WHICH — OH, THE THING ABOUT "TAKING SPACE"? HER FAVOURITE PHRASE.

HER FAVOURITE PHRASE.

BUT YES, THE PART WHERE BEING IN A DIFFERENT CITY TO THE FAMILY WILL DO WONDERS FOR YOUR SENSE OF SELF.

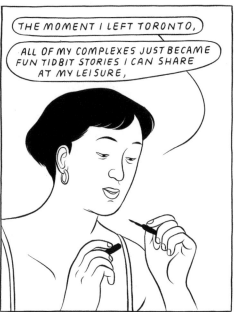

THE MOMENT I LEFT TORONTO,

ALL OF MY COMPLEXES JUST BECAME FUN TIDBIT STORIES I CAN SHARE AT MY LEISURE,

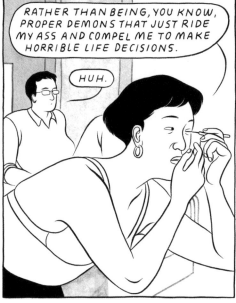

RATHER THAN BEING, YOU KNOW, PROPER DEMONS THAT JUST RIDE MY ASS AND COMPEL ME TO MAKE HORRIBLE LIFE DECISIONS.

HUH.

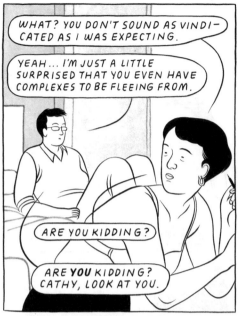

WHAT? YOU DON'T SOUND AS VINDI-CATED AS I WAS EXPECTING.

YEAH... I'M JUST A LITTLE SURPRISED THAT YOU EVEN HAVE COMPLEXES TO BE FLEEING FROM.

ARE YOU KIDDING?

ARE **YOU** KIDDING? CATHY, LOOK AT YOU.

WAA, THAT DAUGHTER OF HERS, GETTING EVEN MORE PRETTY, AH?

REALLY? SHE'S FINALLY STOPPED WEARING ALL THOSE UGLY MEN'S CLOTHES?

NO, NOT ANGELA! CATHERINE!

OH, CATHERINE, YES, ALWAYS SO PRETTY!

SO MUCH BEAUTIFUL HAIR, SUCH A SHAME TO CUT IT SO SHORT.

GOING TO BE HARDER TO GET A HUSBAND WITH HAIR THAT'S SO — EH, THAT'S ENOUGH SALT!

ALEXANDER IS DOING LOW SODIUM FOR HIS **HYPER-TENSION**, YOU KNOW.

YOU'RE THE HOT STRAIGHT ONE! MUM WOULDN'T EVEN POST PICTURES OF ME ON FACEBOOK FOR A WHILE.

REMEMBER WHAT HAPPENED AT MAHMAH AND YEH YEH'S 50TH WEDDING ANNIVERSARY?

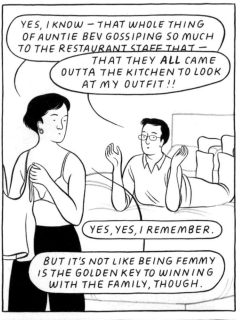

YES, I KNOW — THAT WHOLE THING OF AUNTIE BEV GOSSIPING SO MUCH TO THE RESTAURANT STAFF THAT — THAT THEY **ALL** CAME OUTTA THE KITCHEN TO LOOK AT MY OUTFIT!!

YES, YES, I REMEMBER.

BUT IT'S NOT LIKE BEING FEMMY IS THE GOLDEN KEY TO WINNING WITH THE FAMILY, THOUGH.

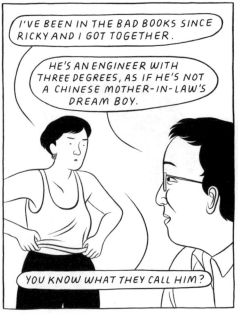

I'VE BEEN IN THE BAD BOOKS SINCE RICKY AND I GOT TOGETHER.

HE'S AN ENGINEER WITH THREE DEGREES, AS IF HE'S NOT A CHINESE MOTHER-IN-LAW'S DREAM BOY.

YOU KNOW WHAT THEY CALL HIM?

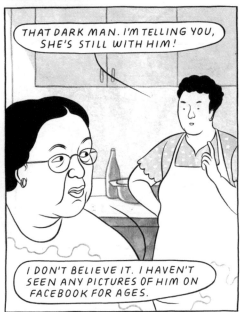

THAT DARK MAN. I'M TELLING YOU, SHE'S STILL WITH HIM!

I DON'T BELIEVE IT. I HAVEN'T SEEN ANY PICTURES OF HIM ON FACEBOOK FOR AGES.

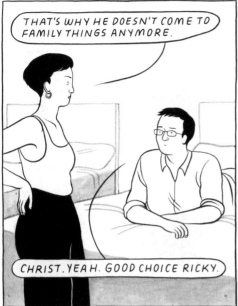

THAT'S WHY HE DOESN'T COME TO FAMILY THINGS ANYMORE.

CHRIST. YEAH. GOOD CHOICE RICKY.

BUT ANYWAY, YOU'RE STILL THE HOT STRAI—

OK, YOU'VE BEEN ABLE TO WHINE ABOUT BEING GAY AND WEIRD SINCE WE WERE TEENAGERS.

I KNOW IT SUCKS THAT HEIDI WILL FOREVER BE YOUR 'NICE FRIEND' BUT IT'S NOT LIKE THEY DONT **KNOW**.

THEY TOTALLY KNOW, IT'S JUST THAT NOBODY TALKS ABOUT IT.

...

YOU'VE COME TO FAMILY GATHERINGS FOR OVER A DECADE WEARING **THIS** KINDA THING,

AND AUNTIE BEV STILL MAKES YOU THREE TRAYS OF LO BAK GO TO TAKE HOME, EVERY TIME.

I GET TO TALK ABOUT MY HOT STRAIGHT GIRL COMPLEXES TOO.

WELL, IF HE **IS** OUT OF THE PICTURE THEN I CAN INTRODUCE HER TO MY NEIGHBOUR'S SON, HE HAS A GOOD JOB IN I.T.

YES, INTRODUCE HER! CATHERINE SHOULD FIND A NICE MAN BEFORE SHE'S LESS PRETTY, SHE'S NOT SMART LIKE ANGELA.

YES, ANGELA – SO SMART, THAT GIRL.

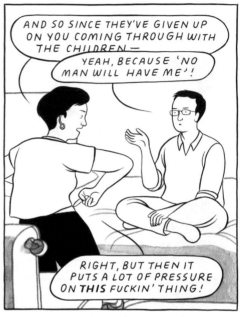

AND SO SINCE THEY'VE GIVEN UP ON YOU COMING THROUGH WITH THE CHILDREN —

YEAH, BECAUSE 'NO MAN WILL HAVE ME'!

RIGHT, BUT THEN IT PUTS A LOT OF PRESSURE ON **THIS** FUCKIN' THING!

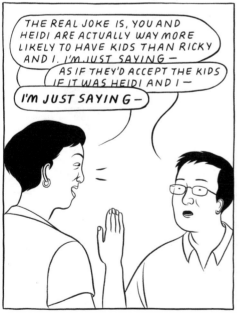

THE REAL JOKE IS, YOU AND HEIDI ARE ACTUALLY WAY MORE LIKELY TO HAVE KIDS THAN RICKY AND I. I'M JUST SAYING —

AS IF THEY'D ACCEPT THE KIDS IF IT WAS HEIDI AND I —

I'M JUST SAYING G —

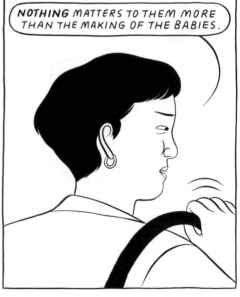

NOTHING MATTERS TO THEM MORE THAN THE MAKING OF THE BABIES.

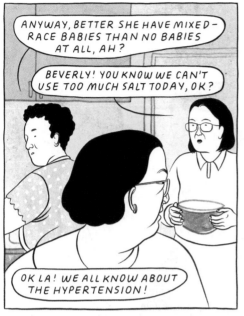

ANYWAY, BETTER SHE HAVE MIXED-RACE BABIES THAN NO BABIES AT ALL, AH?

BEVERLY! YOU KNOW WE CAN'T USE TOO MUCH SALT TODAY, OK?

OK LA! WE ALL KNOW ABOUT THE HYPERTENSION!

WHAT ARE YOU TWO TALKING ABOUT?

JANINE, IS YOUR CATHERINE STILL WITH THAT DARK MAN, WHAT'S-HIS-NAME?

OH, YES. BUT SHE SAYS HE CAN'T COME TODAY, TOO MUCH WORK. ALWAYS SO BUSY.

AH.

MM.

SIGH

I CAN'T BELIEVE IT'S BEEN TWO YEARS SINCE WE'VE BEEN ABLE TO GET TOGETHER AND WE'RE **STILL** JUST ARGUING ABOUT WHICH OF US INCURS MORE SHIT FROM THE AUNTIES.

I KNOW. I'M SORRY.

...I DON'T THINK HEIDI AND I ARE GOING TO HAVE KIDS, BY THE WAY.

WHAT? REALLY??

WE'VE TALKED ABOUT IT A LOT OVER THE PANDEMIC. I THINK WE'RE BOTH JUST TOO AMBIVALENT. A PROPER NO FOR YOU AND RICKY, THEN?

NAH, FUCK THAT CHAOS. I LIKE MY LIFE.

SNORT

WEREN'T WE TALKING ABOUT HOW I'M RIGHT ABOUT SOMETHING, THOUGH?

OH YEAH. I GUESS I WAS JUST SAYING THAT I SHOULD'VE DONE WHAT YOU DID AND LEFT TORONTO YEARS AGO.

I FEEL LIKE I'VE CHANGED SO MUCH IN SUCH A SMALL PERIOD OF TIME.

THAT'S REALLY COOL. I THINK I'VE CHANGED A LOT, TOO.

EVERYTHING'S CHANGED A LOT.

NOTE: THANKS TO YARIJEY AND SAMIA FOR THE
CONVERSATIONS THAT HELPED FORM THIS SCENE

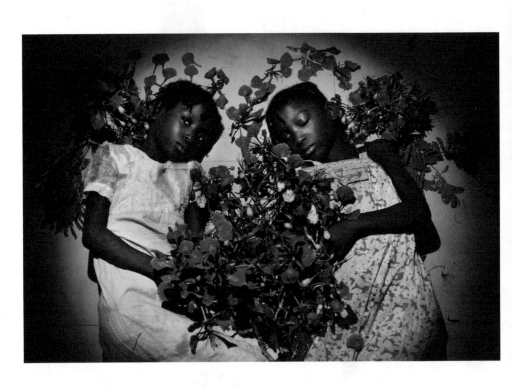

BÉNÉDICTE KURZEN & SANNE DE WILDE / NOOR
Twins pose with local flowers, Gwagwalada, Nigeria, 2018

BETWIXT AND BETWIN

Taiye Selasi

Strange

You and your sister are five years old. You are told not to talk to strangers. Strange, you think, as strangers seem to love to talk to twins. 'Which one's older?' Crouching and smiling, pantomiming comparison, swivelling their heads and darting their eyes from you to your sister and back again, scanning your bodies in a manner that anyone would otherwise find inappropriate. As if playing a game. As if, moreover, you have asked them to play.

Around this age you happen to watch a man approaching a family dog – a retriever of some common sort – while playing in the park. The dog belongs to a family that is eating on a blanket nearby. It sniffs around beneath a tree, trailing its leash through leaves. The man, smiling, approaches the dog. It pays the man no notice. The man crouches down and pets the dog. It carries on nosing the leaves. The family look over and see the man. He smiles at them politely. The family understand that all is well, smile back and carry on eating. The man pulls a stick from the leaves and stands. The dog walks a circle and sits. The man throws the stick a few metres ahead. The dog

doesn't move, panting lightly. The man retrieves the stick himself and tries again, throwing farther. The dog, as if understanding now, appears to play along. It trots through the leaves, picks up the stick, then, flatly ignoring the man, trots to its family and sits, panting heavily, pantomiming fatigue.

Smile

It is your habit in childhood to frown at strangers, smiling ones in particular. In the photos that survive adult relocation – photos of you and your sister with family, taken in a range of locations by strangers – you are always frowning. For years you believe that these photos confirm your mother's allegations, that you were the 'difficult' one of the two, much harder to rear than your twin. But when you are a mother yourself you start to doubt your mother's word choice. Finding your frown on your daughter's face, you understand its source – not a difficult girl but a guileless one, the absence of any mask. The bulk of the photos are of you and your sister. In these you are always smiling, an arm around her shoulder and your two heads tilting in. No one ever instructed you to stand in this way, that you can recall, but from five years old until fifteen more or less the pose remains: you on the left side, she on the right, your arm outstretched to hold her, long, her right hand gripping your thumb at her neck, her left brain touching your right. Were a sculptor to craft a bust of you both this would be its form. (No photos survive, if any were taken, of either of you on your own.)

It is your sister's habit in childhood (idem: one childhood containing two children) to smile at strangers, smiling or not, particularly when not. She is smarter than you in this regard, she understands the game; the expectation that twins like dogs will always want to engage; the preference of strangers and mothers both for girls who play along. It is both of your habit to mirror each other when finding yourselves

in some new situation. Shoulder to shoulder, facing forward, neither can see the other. Nevertheless, your two faces take on precisely the same expression. Frowning brows and smiling lips, a meeting in the middle. Which one of you is older? *Fetch.* Together: She is / I am.

Second

According to the hospital you were born a minute and a half before your sister. According to you a minute and a half cannot possibly make you older. Surely the surgeon could have scooped you out second, or scooped her out sooner? Does it take *ninety* seconds? To mop up the membrane and cut through the cord? Such an arbitrary number shouldn't matter. But you say it so often, or sing it, in chorus, your two voices one, breathing life into sound – *a minute and a half, a minute and a half* – that the words become matter themselves.

Singular

You and your sister are ten years old. You visit an aunt overseas. She is a friend of your mother, in no way related, your favourite kind of auntie. In the main you dislike the other sort, your blood relations they call themselves, a phrase that calls to mind soldiers covered in blood on a battlefield. And this is in fact how they speak of it, family, of the concept in general and of each other specifically, as if family were war: violent, zero-sum and a thing to be survived. The non-relations are also survivors – of men, you conclude, overhearing – but have not become soldiers, easily angered and shockingly hostile to children. This one, childless, lives in a flat full of pillows she purchased while travelling abroad: pompoms from Morocco, mud cloths from Mali, raw silks from India, China. When speaking, she tends to laugh and

gesture, making her bangles jangle. She smokes, her voice is hoarse, the laughter deep, a kind of thunder. 'What would you like to do today?' she asks you over breakfast, pouring, stirring champagne into orange juice with the handle of her egg spoon. 'Something you've never done,' she adds, licking the handle clean. 'What's something you've never done that you would like to do today?' You look at your auntie. Together: 'Me?' She thunders laughter. 'You and you.' Pointing the spoon at each in turn. 'And you.' Gesturing to both. Jangle, jangle. 'This is the problem with English,' she laughs. 'There should be two different words.' Jangle, jangle. 'How can you tell when someone means just one of you or both?' You consider. Your mother says you-and-your-sister when talking to you-singular about you-plural. Have you-and-your-sister cleaned your room? Did you-and-your-sister hear me? The phrasing has never struck you as strange but yes, you see now, it is. Five syllables where one would suffice. The language is clumsy, burdensome. But your beloved auntie is wrong, you think. There should be three different words: *you* the somebody, *you* the somebodies, *you* the unit – the bodiless whole, greater than the sum of its two-headed parts, disembodied beyond disaggregation.

Scientist

And always *which one* in lieu of *who*. Another telling word choice. A *who* is fully singular. A *one* belongs to two. Or: A *one* with 'which' belongs to two. A one with 'the' is on her own. The difficult one. The easy one. The artistic one. The scientific one. A second game that strangers, friends too, love to play with twins. It happens, you know, with siblings as well, brothers and sisters, perhaps more with sisters. Your girlfriends with sisters similar in age, whether older or younger, report as much. The difference, you insist, is the aim. Sisters are compared, twins are studied.

Everyone becomes a scientist when meeting twin sisters, instantly committed to research, to quantifying $|d|$ = deviance from absolute identicality. 'But you don't look the same' is where this begins, the 'but' confrontational almost, that most glaring deviation recorded at once: You and your sister are fraternal.

Italians, you learn, call identical twins *veri gemelli*. Real twins. Fraternal twins are *falsi gemelli*. False twins. Knock-off handbags. The scientists – on learning that you and your sister aren't veritable *veri gemelli* – should quit, but with a fervour that seems to be fuelled by your falseness, they press for facts instead. Unidentical, yes, but how unidentical? Deviation – $|d|$ – must be graphed. Where is the difference? Intelligence? Attractiveness? Interests? And where is the sameness? There has to be sameness if you are twins. If there isn't it has to be invented. You and your sister look nothing alike. You resemble different parents. She is slim and petite with your mother's sweet face, round eyes, archetypically feminine. You are all hard lines like your father, all limbs, much taller at ten than your sister. Those who don't know or aren't told that you're twins rarely guess that you're even related. You share facial expressions but no facial features. The scientists cannot accept this. They squint at your faces, narrowing their eyes, narrower and narrower, blurring your features, blurrier and blurrier, until aha! Same smile, they say, different teeth.

This is the first recording: Same/different. The second: Either/or. Example. Your sister plays piano effortlessly well, right from the start, a gift. Her fingers are startlingly strong for a child, especially a child so skinny. As your mother enrols you in all the same lessons (a misapplied notion of fairness) you play piano too, quite well, but lack all native grace. Your talent, and passion, is drawing. A similar gift for the arts one might say. But similarity, perfectly acceptable in siblings, is bitterly disappointing in twins. Were both of you musicians, e.g., twin violinists, a virtuosic duo playing Bach, sawing away at the double concerto – now this would excite the scientists. Identically artistic!

$|d| = 0!$ With your talent compounded by your twinship, and each of you considered a better violinist individually than the lone child-soloist. Alas. You, a pianist and a painter, are neither excitingly different nor excitingly same, and the scientists, in need of excitement, scrap same/different for either/or. Which one's the artist? You or her? *We are.* Wrong answer. *We* isn't *one.* And if you are the artist, the right-brained one, then she must be left-, the logician. This happens so often and for so many years that both of you start to believe it. Your childhood talent is draughtsmanship (for you, a mathematical practice) but you trade your Tombows for tempera. Why? The artistic one should paint. Your sister perfects Paganini/Liszt then promptly abandons piano. The logician, however musical, should focus her efforts on maths.

If one aims to compare two things, you insist, one sets them side by side. You and your sister are set, instead, one on top of the other then blurred, made to appear as a single like thing and then broken apart into opposites. Broken apart, blurred together, broken apart, blurred together. Your sameness (unreal) insisted upon. Your similarity (real) ignored. This is what siblings cannot understand. This is what they do not suffer.

Size

You are fifteen years old. You are spending the night at the home of a friend of yours (plural). This friend and your sister are in Maths Club together, the friendship is theirs more than yours (singular). But neither can see this yet, you nor your sister, you call her our friend with unquestioned conviction and on, you see later, the unspoken understanding that all of your friends must be both of your friends. Your friendships are triangles: you at the base points, the friend, equidistant, at the apex. The idea of a friend that is yours but not hers is a line, and a line you don't cross. As your mother requires you

to take the same lessons, you require each other to form the same bonds, a rule that you never acknowledge but vigorously, mutually and mutely enforce.

The parents of this school friend have known you for years. The triplets, they call you fondly. The mother is gentle, a paediatrician, the father is cheerful and loud. At dinner he applauds your sister's appetite. Refreshing to see in a girl. 'Cause she never gets fat,' says the friend, also cheerful and loud. 'The skinny twat!' The mother, miraculously, never gets angry. 'That's one way to put it,' she laughs. 'It's common for second-born twins,' she adds. 'Owing to the very low birth weights.' You are thinking that 'second-born' is better by far than one and a half minutes younger or apart (*how far apart are you?* parted again) when your sister speaks up beside you. 'Or owing,' she says, 'to the first-born twin taking all of the food in the womb.' The mother, the friend and the father laugh. You choke on the water you're drinking. 'I didn't take all of the food,' you splutter, seized by the fear that you did.

You have always been taller than your sister, as said, but you grew in a new way in summer: You are big-boned with breasts, she is bird-boned without; she looks months and not minutes apart. More. Parted by more than mere months. By heavier. Menstruation. Weight. Blood. The laughter, once cheerful, sounds hostile, your sister's especially an accusation: *You* are to blame for the difference in size, which is not just a difference (as you have believed) but a deficit rather. Just look at you two. Just look. At your flesh. And her bones. Your sister is right. You took too much. 'Of course you didn't!' The mother is still laughing. 'You had separate placentas.' She winks at your sister. 'Fear not! I treat skinnier singletons!' You and your sister frown-smile. The friend giggles. 'Singletons?! Are twins called doubletons?!' The father, still howling, slapping the table, spills his wine on the eyelet lace. The mother speaks over his jovial cursing. 'No, dear. Twins are called multiples.'

Morning. Your mum drives, you in the front, your sister in back behind you, both of you resting a cheek on a fist and a shoulder against a window. 'Did you and your sister hear me?' Silence. 'I said was the sleepover fun?' You haven't looked at each other since leaving the table, since food in the womb became zero-sum, but see yourselves now in the front and back window, your two blurred reflections. Mourning.

Singleton

At university you date a mathematician. You (singular) are twenty years old. He is tickled to discover not one but two words with one meaning to him and another to you. 'A singleton,' he says, 'is a set containing one element.' You blink, confused. 'Natural numbers that are neither prime nor composite.' You blink, still confused. Looking for his notebook, he tries again. 'The set of all even prime numbers?' He is never without a notebook this mathematician, any notebook, the cheap sort, he buys them in bulk, pocket-size, spiral-bound, all of them tattered, nothing like your leather-bound sketchbook. He praises your paintings but teases your preciousness; asks if you know that the brand is a hoax? Moleskine, created in 1997, has nothing to do with Chatwin or Paris. In truth, you envy the ease of his genius, the furious scribblings in Pep Rally pencil, equations filling pages then scratched out unfinished, his comfort with starting from scratch. He pats the duvet, a notebook pops up. He opens at random and writes:

The set of all even prime numbers = { 2 }
The set of months beginning with the letter N = { November }
The set of American states ending with the letter K = { New York }

'Multiples,' he continues, 'are numbers you get when you multiply a number by an integer.' You laugh. 'Bloody hell. Maths is so fiddly. What's the difference between a number and an integer now?'

When you end the relationship after a year and a half, he sends you a package in the mail. A pocket-sized notebook, empty it seems, a gesture, you toss it aside. Months later you find yourself needing to jot down some airline record locator. How you manage, spotting that notebook in haste, to open to his note you don't know. In the middle of the page, in Pep Rally pencil: *1.5 isn't an integer.*

Space

In Rome a man you fancy comes to fetch you on his scooter. You are twenty-five years old, summer, evening, velvet breeze. Your feet slip off the foot pegs as he circles the Circus Maximus quickly, gliding towards the Palatine Hill, the 'Wedding Cake' beyond. You can't find a place to rest your feet, or you can't find a way not to have any feet; he showed you the place when he kicked out the pegs as you mounted the scooter in Monti. Now your flip-flops keep brushing his slip-ons, made of some soft salmon suede that looks edible, and you fear that your feet are encroaching. An old and irrational preoccupation. When sharing a thing (no matter what) with one other person (no matter who), you labour with the fear, an obsession almost, that you are taking too much. A dessert with a girlfriend. A bed with a boyfriend. An armrest on a plane with a neighbouring stranger. The floorboard of a Vespa with a soon-to-be husband. But where to put your feet? At a red light several Vespas stop beside you, one quite close. The driver is wearing an elegant suit and an exceptionally bulky helmet. He looks like a well-dressed warrior, you think. A centurion with a stylist. The woman behind him is holding his waist with a delicate grip and an upright back, her lipstick is red, her stilettos are pink, perched on the foot pegs, flamingos. Their Vespa goes, your Vespa goes, the thrill again and the velvet breeze, the Roman pines in silhouette like hulking heads of broccoli. You copy the woman, holding on, putting your feet in their place.

Sister

The Roman writes for *la Repubblica*. His hero is Hunter S. Thompson. 'We are all alone. Born alone. Die alone'. You snort. Does he use that line on all the girls? And no. You weren't. Born alone. 'So there are two of you!' Just one. Of you. And one of her. He laughs. Rs roll. 'Then you'll adore the story of Rome. *Eet*'s a story of *tweens*.'

You park in Piazza del Campidoglio. He brings you to the statue. A wolf from whose nipples, two of the eight, cherub-like babies suckle. 'The twins,' says the Roman. Romulus and Remus, left on a riverbank to die by exposure (like Moses, you propose) then found by a she-wolf and nursed until found by a shepherd. 'The story of Romulus,' the Roman goes on – but here you interrupt, rather startling you both, the words bursting forth before you are even aware of having thought them. 'The story of Romulus *and Remus*,' you correct him. 'And why must Remus come second?! Do we even know which –' you correct yourself – 'who?! Do we even know *who* was born first?!' Blushing, you stop to catch your breath. Misinterpreting, he chuckles, thrilled by what appears to be your interest in the history. 'No one knows which was born first,' he concedes. 'But Remus died first so comes second.' You frown. 'How did Remus die?' He shrugs. 'Nobody knows that either.' You laugh. 'But how can a myth of such obvious importance exclude so important a fact?' Now the Roman is quiet, an uncommon occurrence. Like many *romani* he is partial to chatter. 'I suppose,' he says finally, 'it *isn't* important. Romulus, not Remus, founded Rome.'

In fact, you learn, the twins wish to found a 'city on a hill' together but they can't agree which, the Aventine Hill or the Palatine minutes away. The Roman is right. The details differ but the plot remains the same: Remus humiliates Romulus in public, Romulus rages, Remus dies. Romulus, as king, bestows upon Remus full funeral honours. It is now widely agreed that Romulus murdered Remus. Still, he mourns.

This troubles you greatly. You wander the city, and later the country, pressing for facts. You travel to a monastery in Lombardy to inspect a fifteenth-century frieze. You write a doctoral thesis in History of Art on representations of fratricide. You find, notably, very few women killing their sisters (they more often kill themselves) but innumerable men – envious, scheming, wounded – offing their brothers. Set and Osiris, Cain and Abel, Michael and Fredo Corleone. As if sisters at odds can coexist in discomfort but brothers quite simply cannot. You consider, again, fraternal twins. *Frater* meaning brother. Fraternal sister has always seemed a contradiction in terms. But perhaps, as advertised, fraternal twin sisters *are* false? *Falsi gemelli.* Not false as twins but false as sisters. Fraternal twin sisters are brothers.

Stranger

You have a baby (a girl). You are pregnant (a girl). You have just turned thirty years old. You and your sister send texts on your birthday but you do not talk. You are strangers. Your husband (the Roman), who talks to his mum at least once every day, can't accept this. 'But you are *tweens*,' he says. 'What happened?!' You shrug. You are twins. That is what happened. He still can't accept this. He is looking for scale. A decades-old rivalry, an epic betrayal. There is nothing. Remus scaled Romulus' wall. What did Abel do to Cain?

Split

You and your sister invent your own language as infants, a common occurrence in twins – derived, some say, from the sounds of the womb, the blurred hum of heartbeat in water. No sounds survive. Twins must be made to forget as quickly as possible. You won't learn to speak the

world's language, say doctors, so long as you carry on speaking the womb's. As twins tend to babble most freely at night (reminded of the dark of the uterus, you think) the recommendation is to split them apart when they sleep. This seemed logical before. Now, as you sleep-train your one-year-old daughter (or try to), it seems cruel. The Roman finds papers from peer-reviewed journals in which researchers present the same finding: leaving an infant to cry it out has no adverse effects on mother–infant attachment. He is, he assures you, happy to use whichever method you like. But you rock her on Monday, camp out on Wednesday, let her cry it out on Friday, nurse her to sleep on weekends. 'You are,' he says, 'betwixt and between.' He is right, of course, and he uses that phrase in particular to make you laugh. You don't.

When you finished your thesis research in Rome and returned to London, you attempted long distance. Both of you hated the endless texts and phone sex, and you split. The endless texts and phone sex continued. Finally, he put his foot down. At the time, when texting in English, he used Italian phonetics unknowingly. Wow spelled as *uau*. These spelled as *this*. He emailed an ultimatum. *I can be your friend, I can be your husband, I cannot be betwixt and betwin*. You laughed until you cried. He uses the expression whenever he wants you to laugh.

You cry. Sat in the hall on the hardwood floor with your back to the door of her nursery, watching black-and-white baby-cam footage until the timer chimes – you cry. No adverse effects on mother–infant attachment, bully for mothers and infants, but what about twins? Infant twins? What about twin–twin attachment? If the infant believes – as the sleep blogs warn, with ominous terms like 'undermined trust' – that the mum who won't come when it cries is gone forever, what of the twin? Did you and your sister believe that the being with whom you were formed and born was dead? And in whom was your trust undermined? Trust in your mother? Or trust in the other?

Shadow

In your bedroom you dress for a dinner party. In your bathroom your daughters play. They remind you, at thirty-five years old, of you and your sister those decades before. After a moment you notice with sudden alarm that all has gone silent and panic; they're their father's daughters after all, congenitally incapable of quiet. But the elder is here in your bathroom doorway, stretching both arms to the door frame, brimful, frowning brows and smiling lips, just about to laugh. You don't see the younger. (Six and five.) Where has she gotten to? 'HERE!' She leaps to the side from behind her sister's back where she was hiding. 'You couldn't see me!' 'You couldn't see her!' They repeat their trick at your mirror. The elder, holding her arms out, praises the younger hiding behind her. 'You can't see you at all!' (She uses the second person.) 'See?' But the mirror is blocked from the younger's view as she is blocked from its and, shifting her face to the left of her sister to see the illusion, she breaks it.

You think of the frieze. A decorative medallion of Romulus and Remus at Certosa di Pavia, in which Remus' profile appears as a double of Romulus' or else as a shadow. Your daughter's face, emerging to the left of her sister's, looks precisely the same: a double that breaks the illusion of erasure. She hides again, laughing, restoring it. Laughing, you see, because the erasure is voluntary first and reversible second. Your two daughters' trick is to make themselves one, a trick that *they* play on others. But it was *others* who played this trick on you, making you one in their minds, an amusement, always disappointed that you were still two – as perhaps you, too, came to be in the end? Denied even the ways that you wished to be one, or were, when allowed, left alone, babbling away in your whale-song in darkness, two heads touching, a whole. ∎

TOM WOOD
To McMorrows for a Pint, 1991
© DACS/Artimage 2022

RAIN

Colin Barrett

As Scully and Charlie Vaughan passed under the trees in the town square, the afternoon seemed to switch on and off around them. It had rained while they were in the shops and the leaves above their heads had that dark, weighted gleam they got after rain, the sun a fitful flicker in the gloomy upper tangles of the branches. The stretch of footpath that ran beneath the trees was only lightly spattered where the rain had succeeded in dripping through the foliage; the rest of the footpath, exposed to the elements, was a blasted wash of concrete, scoured to a dark shine.

Scully, sixteen, was hefting a bag of ice on her shoulder. Charlie, Scully's thirteen-year-old sister, was carrying two shopping bags containing a two-litre bottle of Coke and a big carton of milk, several packets of chocolate digestive biscuits, a bunch of unripe, hard green bananas, a slab of butter, cheese, a squirty thing of mayonnaise and a box of teabags.

There was a small fountain in one corner of the square. As they often did, separately and together, the Vaughan sisters paused to inspect the stone bowl of water. With a familiar, and by now almost gratifying, charge of disappointment, Scully immediately saw that the small dull discs littering the trembling floor of the fountain were almost all coppers. Worthless ones and twos, nothing you'd chance a wet elbow for.

Next to the fountain was an old, mutilated public payphone.

'See that?' Scully said.

'What?' Charlie said.

'That,' Scully said. There was a rectangular white card, a little smaller than a postcard, taped to the payphone's battered housing.

'What's that, now?' Charlie said, leaning in and screwing up her eyes. A sentence was printed in black type on the card.

IF ASHA CALLS TELL HER GO HOME, Charlie read. 'Who's Asha?'

Scully let the bag down onto the footpath. Her neck and jaw on her left side stung, and the collar of her T-shirt was damp and nubbled, like a teething baby had been chewing at it.

'That note's been there for the last week,' she said. 'I've been trying to work it out.'

'What's there to work out?' Charlie asked, 'If Asha calls, you tell her go home.'

'It's just that whoever made this note put it here because they reckon there's a decent chance Asha will call this particular phone,' Scully said.

'OK,' Charlie said.

'But why would Asha be ringing this payphone?' Scully asked. 'She must be ringing to talk to someone. Someone *specific*, someone she has to go through the hassle of contacting on a public payphone.'

'So the note is for that person,' Charlie reasoned.

'Or for me. You. Whoever happens to answer when Asha calls.'

'And then we tell her: go home!' Charlie said.

'It's been at me,' Scully said, 'how the person who wrote this knows enough about Asha to know there's a decent chance she's making calls to this payphone. But for some reason they can't locate or contact Asha directly themselves, or else why go through the effort of putting up this note in the first place?'

Charlie blinked and thought about this. She pressed the heel of her palm against her temple and ran it up into her hairline. Her hair was short and dark and went up in skunky puffs. As her fingers swept over her hairs they sprang back up. Charlie's eyes looked

small and preoccupied. It was only then that Scully realised Charlie wasn't wearing her glasses, that she must have left them back at the apartment.

'Maybe she's like a runaway, and it's a note from a parent?' Charlie suggested. 'Who knows she's around, but they don't know where.'

'But the way they put it,' Scully said. *'Go home.* Not *come home.* Like it's an order. And an angry one.'

'Parents give orders.'

'But if you wanted someone who ran away to come back . . .'

'That'll be a bag of water you're carrying if we don't get going soon,' Charlie said after a while.

Scully hauled the bag of ice back up onto her shoulder and adjusted her grip to make sure it was secure. They resumed their course and left the square. As they made their way along the streets of the town, Scully had to regularly transfer the bag of ice from one shoulder to the other. Soon both of her shoulders were cold and wet and buzzing with numbness, like a punched lip.

They arrived at the woods on the edge of town and crossed a small ditch onto a path of pale brown dirt. The path climbed a hill into the woods. The trees in this part of the woods were almost all conifers, their needles glimmering with rain and their tops pointing straight up.

'You ever even used a payphone?' Charlie asked as they walked through the trees.

Charlie's question made Scully remember a scene from a movie; a car in an American city at night, screeching to a stop in a dark side street. A man hurriedly exited the car and dashed into a telephone box. The telephone box was illuminated with a scathing brightness, like a medical booth in which large, living things were sterilised. The man had thick, anguished eyebrows. Scully remembered a close-up of his hairy-knuckled hand as he nervously slid a coin into the slot, each hair on his knuckle dark and distinct, like a coil of black thread sewn into his skin. She remembered the noise the coin made as it descended through the belly of the phone; a hollow *ratatat* like a

pebble rolling along a corrugated roof before dropping off the edge into nothing.

The sisters entered a clearing, and soon were coming down the other side of the hill, towards the parking lot at the rear of the block of apartments where they lived.

Scully did not remember anything else about the movie, just that scene, and the lonely rolling noise of the coin in the payphone.

There was no fence around the car park, allowing them to walk straight onto the tarmac. The car park was, as usual, near empty. The apartment building was run-down, its cream facade faded and stained grey. The sisters took the exterior stairs to the second floor, blunt tufts of grass sprouting from the cracks in the concrete steps. At the door to the apartment, Charlie slipped off her left runner, shook out a key and opened the door. From the short hallway, they could hear Rain holding court in the kitchen, speaking at a volume and intensity someone unfamiliar with him might mistake for anger. But that was just how Rain sounded when he was happy.

'I'm as well pull out the lot of them and be done!' he scoffed as they entered the kitchen. He was talking to his friend Victor Reilly and Scully and Charlie's mother, Mel.

Rain was sitting at one end of the little kitchen table set against the wall. Victor was sitting opposite. Victor worked with Rain as a security guard in the psychiatric hospital just outside the town, though both had the day off today, and were dressed in their civvies. It was four in the afternoon and they were drinking whiskey and Cokes. Mel was at the counter, noisily sawing the top off a plastic shampoo bottle with a bread knife.

'Pull out what?' Charlie asked Rain, dumping her bags on the kitchen table.

Rain looked squarely at Charlie and Scully then grimaced, baring his teeth in a sudden yellow clench, like he was in pain. He had a coin in his hand and clinked it against a tooth.

'This babby is refusing to go to the dentist,' Mel said.

'Teeth are a burden,' Rain said, rummaging through the shopping

bags and tearing open one of the packets of chocolate digestives. 'I reckon I should pull the lot of them and put a set of wooden ones in instead. Be done with it all for once and for good. What do you think, girls?' He took a bite of a biscuit and pushed the packet to Victor, who raised a brief hand in refusal.

'That sounds dumb,' said Charlie.

Scully popped the freezer door and arranged a space among the various parcels of frozen food already crammed in there. At the back of the freezer she could hear the cooling fan, its vanes shagged with ice, ticking strenuously. A bank of stubbled ice had almost completely encased the freezer's rear wall.

'This yoke needs defrosting,' she said as she worked the bag of ice into the space she had cleared.

'I know that,' Rain said defensively. 'I've a video on the phone I'm going to watch.'

'How was town?' Mel asked.

'It rained,' Charlie said. 'But we missed it.'

With a final stroke of the bread knife the top of the plastic shampoo bottle came off in Mel's hands. There were two halved bottles already on the counter. Scully watched as Mel used a teaspoon to scrape the gel stuck in the bottle into one of the bottle halves. This was one of Mel's tricks for getting that last bit of mileage out of the shampoo. There was always a final amount of gel you couldn't squeeze out of the bottle, so what Mel would do was save up several bottles and once she'd enough take all their heads off and combine their remaining gel. The bottles tended to be a mix of different brands, whatever was on sale at a given time, so they all smelled different, but that didn't matter. The compounded, floral smell of the gels mixed in the confines of the kitchen with the foul chemical tang of the varnish Rain had lately begun applying to his nails in a bid to deter himself from biting them.

'Rain, rain, go away,' Rain sing-songed, to no one in particular.

Rain was around fifty, but Scully did not know for sure. His face was meaty and pitted. There was a swollen, reddened quality to

his features, as if he had recently recovered from an allergic attack, except he always looked like that. He had a bitty, grey-flecked beard and bullish brow, a crushed prominent nose and shining dark eyes set deep in his head. His real name was Johnny Tell. Rain was the name Mel had given him back when they first met, because he looked like a German film director she had liked named Rainer. The name stuck.

'No upkeep is what you want,' he said, baring his teeth again and again tapping the coin against one. 'It's the upkeep of things does you in the end.'

Then he closed his eyes and rested his head against the wall behind him, as if suddenly exhausted. Tacked on the wall over Rain's head were several drawings done by Mel. Mel and Rain had both been – and technically still were – artists, though Rain seemed to have stopped painting ever since he had gone full-time in the hospital. Scully was glad she didn't have to see his work so much any more. Rain had painted abstracts, near identical pictures featuring dense, sombre swabs of muted colour that looked depressing and dreary, like pictures of migraines or terrible weather. Mel's pictures were charcoal and pencil sketches of body parts; sections of torsos, faces with precisely smudged mouths and wary, animate eyes, disembodied hands and feet flexing and gesturing in white space. Scully understood that art wasn't necessarily about being able to draw things skilfully and accurately – the sense she had always gotten was that among those circles responsible for such judgements, Rain's work was held in much higher esteem than her mother's – but Mel could draw, and draw well. Maybe it was not a requirement to be able to draw well in order to be an artist, but Scully reckoned there were few artists around who could draw so well as her mother. Rain couldn't, for example. For a while, back when he still regularly painted, he had introduced into his compositions something approximating human figures, but they had never looked right. They had weird proportions and crude, sloppy detailing, which he insisted was all on purpose.

'Did you see anyone?' Rain said.

'Who would we see?' Scully said.

'Somebody interesting.'

'We met no one I would call interesting.'

'Everybody's interesting,' Rain rejoined, as if it was the girls' fault for failing to generate an anecdote-worthy exchange with some local.

There was a noise in the hall, a creaturely patter, and Rain's two-year-old daughter Tessa, bare-legged in a nappy, came through the doorway in a racing waddle. She was coming straight at Scully, who dropped into a nearby seat and steered her knees just in time to catch the child between her legs. Tessa was in a Cookie Monster T-shirt. She had a rashy, raw-lipped mouth, pale brown hair as thin and fine as an elderly person's. She was wearing a pair of glasses too big for her face, balanced precariously on the nub of her tiny nose.

'Here,' Scully said, snatching the glasses from Tessa's face and handing them off to Charlie.

Natalie, Tessa's mother, followed the child in.

'Tessa, stop,' Natalie said tiredly, though the child wasn't doing anything just now other than idling between Scully's legs.

'She's all right,' Scully said.

'She needs shooting with a tranquilliser is what she needs,' Natalie said.

'You get teabags?' she asked Charlie.

'Uh-huh,' Charlie said as she fixed her glasses back on her face.

Natalie lifted the kettle out of its cradle, held it under the tap in the sink and ran the water until the spout began to drool. She did not ask anyone else if they wanted tea as she took a mug from the press and fixed herself a cup. She turned around, leaned against the counter and glared unhappily at Rain and Victor. Natalie was Mel's younger sister, Scully and Charlie's aunt. She was a tall woman in her mid-thirties, long-limbed and sinewy, the tendons in her neck rising taut as corset boning when she spoke. Her left knee was strapped into an athletic brace. She was the goalkeeper and captain of the local women's football team. She'd done something to her knee in a match the previous weekend.

'I had a dream once that a bunch of my teeth fell out,' Scully said.

'Many people have that dream,' Rain said. 'I've had it, many times. They reckon it's a dream about money. When you're worried about money you dream about your teeth falling out. Do you have money worries, Scully?'

Scully thought about that.

'I don't think so,' she said. 'I mean, I'd like to have lots of it.'

'I'd like that too,' Rain said.

All of a sudden, Victor sprung silently from his chair and swooped in to grab Tessa from between Scully's legs.

'Hup ba,' Victor said to Tessa as she twisted around in his arms to see who had grabbed her, then he tossed her clean into the air.

Scully watched Tessa's body go up, spin, and come back down head first. Her heart froze as she foresaw the awful wallop of skull against lino, but at the last second Victor caught Tessa by the ankles and held her hanging upside down in the air, her head swinging a foot from the ground as she cackled in a hysteria of happy fear. Victor worked her body clockwise, limb by limb, until she was upright in his arms again.

'There you are! I didn't know where you went,' he said. He eased her back down onto the floor, shooed her away and took his seat with a wild smile on his face. Victor was a good deal younger than Rain, only in his mid-twenties. He had a long forehead and was fair-haired, with a generally quiet and deferential demeanour. But now and then, out of nervousness, or some agitated inner surplus of energy, he was prone to saying or doing something sudden and inexplicable, such as the stunt he had just pulled with Tessa.

'The child is not a bag of fucking spuds, you prick,' Natalie said.

'Stop now,' Rain said calmly. 'Victor was only playing. Did you like that, Tessa? Did you?'

Tessa shied at his question and stepped in behind Natalie.

'Enough of this,' Rain said. 'Hand me my sword, Victor.'

He indicated the keychain dangling from a hook on the sill behind Victor's head. Victor took down the keychain and passed it to Rain.

Rain climbed up out of his seat, opened the freezer door, removed

the bag of ice and brought it to the table. With the glimmering silver wedge of the little palette knife he kept on his keychain, he slit the bag open.

'It was considered a great dishonour,' he said as he hacked free several cubes, 'when a Roman centurion misplaced his sword, or let it be taken from him.'

He dropped the ice into their glasses, topped up the drinks, and returned the ice to the freezer.

'Actually, we did see something interesting today,' Charlie said. 'A message left on that payphone by the fountain in the square.'

'There is a payphone still there, isn't there,' Rain mused as he attached the keychain to a belt loop of his trousers.

Scully looked at Charlie. She could see that Charlie, in her innocence, was going to tell them all about the note on the payphone. Scully wished she wouldn't. She wanted to keep the message about Asha between herself and Charlie. Her sense, though she couldn't explain it, was that the message contained another message, hidden in plain sight within it, and that if they thought hard and long enough about it, they could work it out.

'Someone is missing,' Charlie continued. 'You ever meet anyone around town called Asha?'

'Could be I've met one or two Ashas in my time,' Rain said. 'This is the person who is missing?'

'The message on the phone said Asha come home.'

'It said *go home*,' Scully corrected.

'Was the Asha you know young?' Charlie said to Rain. 'We reckon she must be a kid who ran away on her parents.'

'Really, I never met an Asha,' Rain said, 'and though you're right it's probably a kid, that doesn't have to be the case. An adult can run away too, only nobody ever calls it that.'

'What do they call it, then?' Charlie asked in earnest.

Rain held his tongue and smiled. Scully knew he wouldn't answer. He took great pleasure in taking a thought, tying it into a knot in front of everybody, and then just leaving it down.

'I was thinking,' he announced, 'that Charlie and Scully could come to the pub, if they wanted.'

'Charlie's too young for the pub,' Mel said.

'Charlie's too young to drink in the pub. But Charlie may come to the pub if she pleases.'

'I'd like to go,' Charlie said, 'if I'm allowed.'

'Well, I don't think so,' Mel said.

'We're going to watch a film,' Natalie said, her jaw gone tight. 'After Tessa is down, we can have Coke and digestives.'

'They've Coke in the pub,' Rain said. 'They might even have digestives.'

Rain placed the coin he had been ticking against his teeth down on the table, balancing it on its side like a wheel, and set it rolling towards the table edge. Scully came up out of her seat and caught the coin just as it dropped. The coin was of a yellow-brown, almost mustard hue, with an embossed harp on one side and a horse in profile on the other, the valuation 20p inscribed above the horse. It was old money, money from before the last millennium, and had been out of circulation for a long time.

'What do you reckon, Scully?' Rain said.

Scully glanced at her mother and Natalie's wary faces. Usually, it was only Rain that went out. At night, Scully and Charlie stayed in with Mel and Natalie and watched films. That was how it had been for ages, but now Rain appeared to be changing the rules.

He had set the situation up in an interesting way. There was no way Charlie would want to go with the men on her own, which meant the decision was still finally Scully's. But Scully could now make that decision under the pretence of looking out for her little sister – though she actually did want to look out for her little sister! Scully did not love Rain. Maybe she did not even really like him, but after all these years she was used to him, very, very used to him, and if you paid attention, he did teach you things like this, disguised little ways of getting what you wanted.

Scully slipped the coin into her pocket, because there was nothing

else to do with it now that she had it. She looked into the face of her little sister, and saw, as she always did, the sweet heedless openness of it, the hunger for more of the world than they were allowed. Scully could read Charlie's thoughts, just like Charlie could read hers. Scully did not believe this, she knew it. It was just a fact, as solid and hard as the coin in her pocket.

'I'll go if Charlie goes,' she said.

'And I'll go if Scully goes,' Charlie said, just like Scully knew she would. ■

One hot summer's day, my uncle took my older brother and me fishing on a river in Sussex. The river was so polluted with hormones, my uncle said, that the fish were constantly changing sex, and if we ate them we'd grow breasts. We used balls of cheese for bait, our plastic floats bobbing in the beef-stock brown water as we slapped at horseflies.

My brother and I had been thrown together when I was three and he was seven. He was my adoptive father's son from a previous marriage. So he was the rightful chick; I was the cuckoo's egg. There was a lot of jostling in that nest.

We cast and recast, catching nothing but weeds. It was a competition, though I hadn't realised that yet. Everything was a competition to my brother. His float twitched, and he reeled it in. First catch of the day. A muddy little fish jumped out the water on the end of his line and writhed pathetically in the air.

'Aw, it's just a little tiddler,' my uncle said. 'Better throw it back.'

'Just a little tiddler,' I repeated, sing-song style.

I was up and running before my brother had thrown his rod down on the bank. Bare feet through the long grass, blades catching between my toes, squealing like a piglet. He came at me like an angry white snake, tangled my legs, and pressed down on my chest.

'Just a tiddler!' I screamed. He tore up handfuls of grass and stuffed them into my mouth. Peppery buttercups followed. Pale stringy roots with daggles of gritty clay. Tiny purple flowers. Fists and the ferrous taste of blood.

Back home, I climbed up the shelves of the double wardrobe in our room and lay quietly behind the linen with a torch and a book. I'd fixed the green plastic cap from a milk carton over the bulb of the torch, to dampen the telltale glow, the weak grey-green light fuzzing the letters on the page. It was boiling hot in there, and I stripped down to my chequered boxers. I abandoned the book and hunted around for a chicken drumstick I'd taken weeks ago from a Sunday

roast and hidden. I sniffed and licked its leathery husk. Out in the corridor, the floorboards creaked. I flicked off the torch.

On the other side of the wardrobe doors, I heard my brother padding around. Looking under the beds. Kicking aside toys. 'I know you're in there,' he said. 'You'd better come out.' One day, not too far in the future, I'd ward him off with a knife; one day I'd turn around and kick him so hard in the groin that he'd lie curled and shivering for half an hour – but not today.

The doors to the wardrobe opened with a rush of fresh air. My brother's head appeared, the angry snake. He grabbed me by the ankle and reeled me in hard. Just a little tiddler tumbling through the air. I hit the floor with a smack and then he was on me. My brother had a way of tickling where he'd jam his fingers deep into your sides, worrying your guts and your liver. I gasped for breath. 'Stop,' I said. 'Stop. I'm going to . . .'

I let it go. A puddle of urine soaked my boxers and spread across the beige carpet, stinging as it cooled. My brother leapt off in disgust.

So much for our dislike. Was there anything like love? Later, he insisted we take a bath. Both of us, fully clothed. He sat opposite me in his grey tracksuit and ran the hot tap. The bath began to fill with steaming water: lapping at our arses, scalding our belly buttons through our T-shirts. 'Mind over matter,' my brother said. The temperature climbed and climbed and we turned red as crayfish in a pan. ∎

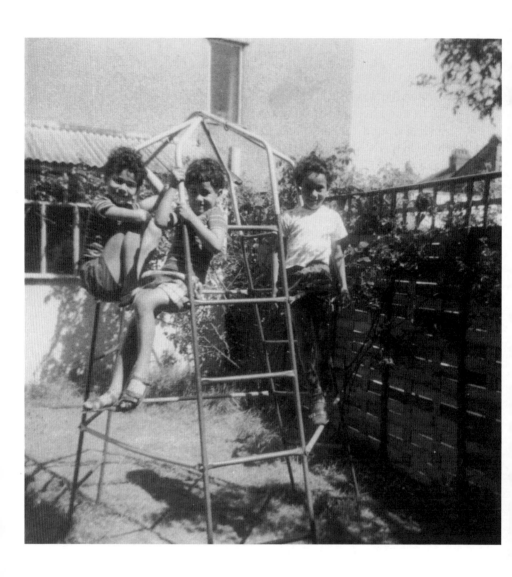

Jamal Mahjoub (left) and his brothers, Liverpool, late 1960s
Photograph by Judith Mahjoub
Courtesy of the author

THE STRIPPING
OF THREADS

Jamal Mahjoub

W hen my brother first came out, I would make an effort to
go and visit him. Back then he was living in a grotty house
in Earls Court – an area he had no connection to, but where he
would remain for the next twenty years. All of his stuff had been
lost when he failed to pay his former landlord. The guitars, records,
books, clothes: all of it was either thrown away or sold when he
went to prison. He was given a tiny room at the bottom of a house
inhabited by other ex-convicts. In the hallways you stepped aside for
former offenders with no idea of what they might have done to wind
up here. Some of them were violent, one threatened my brother with
a knife.

The room was a self-contained flat with a filthy bathroom that you
had to squeeze into sideways. It had an old sash window that offered
a view of a brick-lined light well. High walls you had no chance of
seeing over. Compared to prison it might have been a step up, but it
was a short one. These places are meant to give people a foothold in
society, a chance to improve their situation. He never tried. As if the
will to move on had somehow deserted him, he settled there, signed
on for unemployment benefit and collected his daily methadone.
That was it. In the beginning I suggested he move out of London,
which is expensive, especially if you have no money. I suggested the

south coast. Fresh air, less congestion, probably a better chance of finding work. He wasn't interested.

He was completely isolated. He had no friends that I knew of, no family nearby, nothing around him. Old friends he had known back in Khartoum would ask after him. One or two even tried to look him up. It never came to anything, and eventually they stopped asking. Distant relatives would enquire, but they too stopped. It was basically understood that every family has one who goes astray. Bring him back here, they said. We'll take care of him. But going back to Sudan was the last thing he would do. Go back home with nothing to show for it. So he remained there, lost in the transit hall that is London's maze. The most regular employment he found was volunteering twice a week at a charity bookshop, but that was the zenith of his ambitions. His education was wasted. There seemed no chance of him recovering his vocation of being an architect. And the dreams he'd once had, of becoming a famous musician, were now never mentioned.

Our parents were gone by then. When my father passed away, we contacted the prison to see if we could break the news in person. We all sat in the visiting room on plastic chairs that were bolted to the floor. It was clear that he wasn't happy to see us. The resentment was palpable, clinging to him like stale sweat. He had guessed why we had come, he said. It was as if he couldn't wait for the visit to be over and for us to leave. We were a reminder of a previous existence, one that he had turned away from and that was painful for him to see again.

By the time he came out my mother had also passed. Whenever I was in London I would mark off a day to go over to Earls Court and visit him. We would go for a drink, or maybe a meal. He was my little brother after all. When my children were small I sometimes took them along with me, though they didn't really understand who he was. He rarely showed much interest and had trouble remembering their names. I felt I owed this much at least, if not to him then to the parents who had created and raised us. I was bearing the torch for my father, who used to visit him every Friday after mosque. At the

time I had been angry about this. It seemed to me that my father was trying to pretend that everything was the same as it had always been, rather than face the facts. My brother, after all, had arguably contributed to their ill health. One of the hardest things I ever did in my life was to tell my father that his son was not only taking hard drugs but probably selling them, and that he and my mother needed to be careful. My brother was living with them at the time. I had witnessed the shame my father had felt to see his own son tried and convicted in a British court, a country in which he had spent much of his life trying to prove how civilised and respectable a Black man could be.

In the end duty wasn't enough. My brother saw through my efforts. He accused me of trying to fulfil an obligation, and of course he was right to an extent. I also realised that I, like my father, wanted to pass a couple of hours with him in something resembling normality. The meetings became more strained, and gradually they tapered off. There came a point when it was no longer worth making the effort, when our conversations would invariably veer into argument and bitter acrimony. And so it ended. Since then we have not had any direct contact. I don't see him. He doesn't write or call. He never replied to my emails so I stopped sending them. I have no telephone number for him. From time to time I hear from my middle brother that he is still alive, but that's about it. And the same goes the other way. I am, I think, literally dead to him.

How did it all come to this? I can't help thinking that when we were small the three of us were very close. There are only eighteen months between each of us. After five years without children, my mother suddenly had three boys in quick succession. We were brought up in the same household, played together, shared a room when we were small, went to the same school, slept outside under the same stars. It would be wrong to say we were treated equally. All parents may aspire to impartiality, but in the end factors like character and affinity play a role. They tried, I suppose, but I always thought my father was harder on me as the eldest, and favoured my younger brother because he was

small and cute. He had a nickname for him, whereas he often mocked me. Perhaps that's just the way I remember it. I left home early and my brother stayed late. Our middle brother found his own course, marrying into a rather conservative and wealthy Egyptian family that adopted him wholeheartedly. Not so much gaining a daughter as losing a son, my mother would say. Under their influence he turned to Islam, something we had not been encouraged to do as children. Neither of my parents were firm believers. My mother was at best a sceptic. She hated the hypocrisy of pious people right up to the very end, while my father became gradually more observant, doubling up the five daily prayers to make up for lost time, and making the haj to Mecca.

How can three souls, born to the same parents within such a narrow time frame, and brought up in identical surroundings, find themselves so alienated from one another that they can no longer bear to see each other, and rarely even communicate? This is the question that I keep coming back to, the one I can never quite explain. Only three people in the world shared that specific experience of growing up together, and yet we cannot get along. Whatever bond or allegiance was formed in those early years, it was not powerful enough to overcome our personal choices.

I wonder what measure of this is mine to bear. I wasn't there, after all, in those crucial years when my brother went from a teenager to an adult. I had been awarded a scholarship, which I saw as my ticket to see the world. I was determined to travel as widely as possible, and shut the idea of home out of my mind. I assumed it would always be there for me to return to. But those intervening years were key for him. He discovered a new kind of notoriety, hanging out with people who were older than him, expats for whom Sudan was just a dangerous playground. He fell in with an English guy who set up an illicit bar. Alcohol was banned at the time, but they brought booze in overland from the Eritrean port of Massawa. There were checkpoints on the roads, but it was easy enough to circumvent them by cutting across the desert. Through that gateway came other things, including

heroin. When things got too hot for him, he came to London to join me. By then he already had a problem.

In the end, my mother had no need for my warning. She worked it out for herself. She had just been diagnosed with melanoma and was in London for treatment. She threw herself into trying to understand my brother's problem. She attended meetings for parents of addicts and read countless books on the subject, believing there had to be a way to cure him. It's a natural instinct to try and protect your children from harm, but it was already too late. People get clean because they want to. You can't make them do it. I see now that I had been doing the same thing. Those visits to Earls Court were my attempt to understand. And like my father, I was trying to normalise the situation. Perhaps subconsciously I even believed that I would find the cure, that I could fix the problem. I was also looking for a way to forgive him, for what he'd done to the family, to our parents, for squandering the opportunities he'd been given. When eventually I stopped going, it had become clear to me that I was deceiving myself. I could never forgive him. This thing would always be there between us. I would never understand, and I could never save him from himself.

Eventually he resolved his addiction problems, or at least brought them under control, but he remains caught within the narrow confines of his choices, still unable to move on. He burrowed down into the idea that this was meant to be, this was what marked him out as being special. His acceptance of his fate and those broken dreams he'd made so little effort to achieve, contains no small degree of martyrdom, which is tied to a notion of redemption. The reason it is so hard to forgive him is that although he cannot deny the pain he has caused, he cannot really bring himself to admit it. Underlying everything there rankled a feeling of injustice, a sense that life had let him down, dealt him a bad hand. In his narrative he is always the victim. Our parents are to blame for not instilling in him more discipline. If he lacked inner strength it was because they had been too easy on him. This obsession with self that borders on

narcissism goes some way to explaining the resentment, towards me, towards our parents, towards the world for putting obstacles in his way. It's what makes it impossible for him to have more than a passing interest in anyone else's life. In the end, the only subject left to him is himself.

For a number of years he persisted in the belief that he could somehow vindicate himself, turn his plight into noble sacrifice. With his share of the inheritance, which wasn't a lot, he invested in the stock market, something he knew nothing about. In due course all the money was lost but for a long time he would tell me, rather dramatically, that if something should happen to him, the financial documents were in an ugly old briefcase he kept in a corner of his room. That was his plan, to finally make good on everything by paying back what was, in his mind at least, some kind of fortune. Ignoring the fact that no amount of money would ever make up for the heartache and pain he had caused.

I hold no illusions about us being reunited. All of this has gone on for far too long. The threads that connected us have been shorn off. All that remains is the memory of it and the unresolved mystery about what it all means. Maybe we were simply too close. We know too much about each other. There is a time when we were at school in Khartoum that always comes back to me. We used to have extra Arabic lessons in the afternoons. My father would drive us over to the teacher's house and we would sit in the yard, which was just a small, bare space between the rooms and the whitewashed outer wall. We sat around a table covered with a plastic sheet. One afternoon my brother made a lot of mistakes. I think we were doing dictation. The teacher told him off for not working hard enough. Without a word, my brother got up and ran to the tall metal street door and pulled it open. We watched in amazement, then we all got up and went over to take a look. The house was surrounded by sandy streets and opposite was a football pitch. Again, just a dusty space with a goal frame at either end. The lines were marked in chalk. There he was, halfway across, running through the bemused players with no regard for

the shouts that followed him. Where's he going, the teacher asked, speaking our thoughts aloud. The teacher's younger brother took off and eventually brought him back. It was a funny story at the time, but it always made me wonder. We were far away from where we lived and he didn't have a clue how to get back home. So where was it he thought he was going? I don't think he knew. All he wanted was to get away from where he was and maybe never come back. It was as simple as that. ∎

K Patrick

George

Keep telling me all about men. Like the way George
Michael filled his jeans. Mothers like a man who can
fill his jeans. What a way to put the ache somewhere,
right behind a rigid seam. Stiff denim, stiff upper lips,
stiff country we live in. George Michael I love you we
have something in common. I know enough about
Faith. A little bit of God in the beginning just to prove
there is no God in the rest. As a word, organ has a
beautiful double meaning: songs written in meat
about meat. George after Pride you crashed into that
Snappy Snaps. I think your Mother had recently
passed? Someone graffitied WHAM ! into the yellow
damage. Humans and their ancient ability to make a
joke. You considered yourself cursed. In me this
quality is mostly arrogance. From you I learned how
to fill my jeans – us butches can have it all! An old
lesson from one TV boy to another. Saturdays spent
kissing the old screen to suck you free. Old glass
curved and smooth like a Mother's belly. Saliva
crackling on contact, saliva is a word that goes on
and on if you let it. Like George, like old, like organ,
like Mother. You died on Christmas Day. Don't we
gays love an impossible reconciliation! I mean past
and present, I mean you and me.

LOOKING AT MY BROTHER

Julian Slagman

Introduction by Alice Hattrick

Julian Slagman has been taking photographs of his younger brother for over ten years. A child grows up, becomes a teenager, a young adult. You can see the photographer grow too, experimenting with different styles and approaches, from staged portraiture to more candid snapshots of the child in play, captured from different angles, often from above (as the older and therefore initially taller brother). Fairly little of the 'stuff' of childhood is shown; Slagman's focus is on his brother as he ages, and the marks of experience his body retains, which in this child's case includes the purposeful scars from medical procedures rather than juvenile accidents.

At first, I am looking for signs of scoliosis beyond the healing incisions and purple scars. But Slagman's images also capture human interventions in the natural world: a perfectly straight contrail in the blue sky, the branches of a shrub or tree tethered together to keep it growing upright.

Slagman's photographs counteract the medical narrative as well as the medical gaze. His brother is shown in motion or still, crouched down, or in bed asleep, at bathtime or playtime, times of rest as well

as movement. He is acting out an imaginative battle game with his whole body and facial expression; he is sitting cross-legged surrounded by boxes of Lego; he is facing his brother and then turning away. By including these moments in the series, as well as the stems of the shrub that defies human intervention and control, we are encouraged to look at him another way: as a child, captured inside of time as it unfolds, uneven and contorted. ■

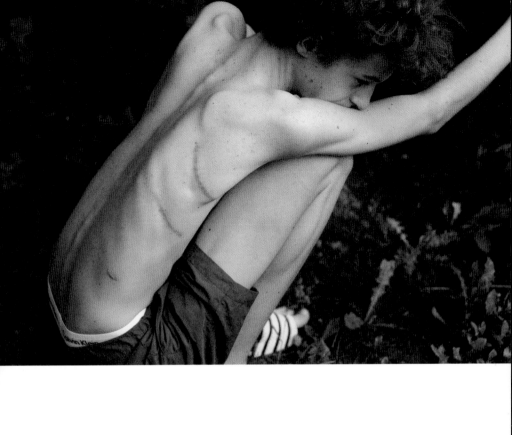

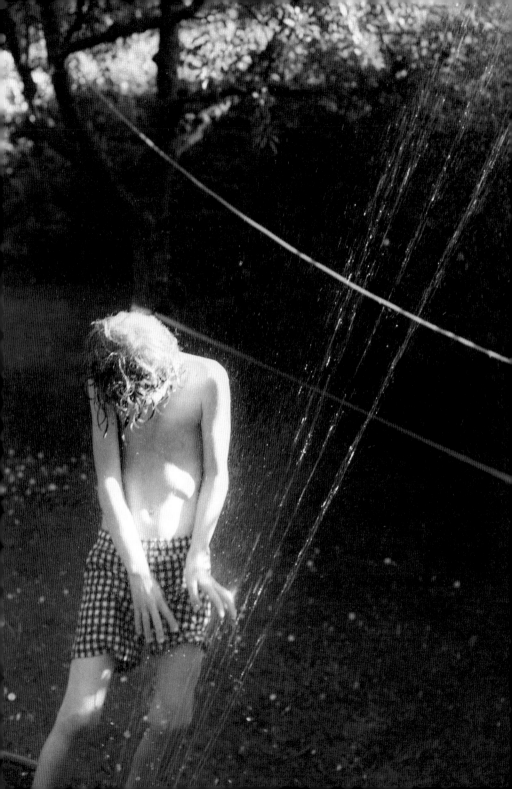

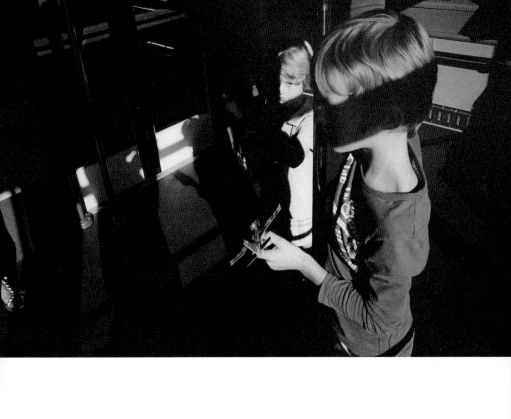

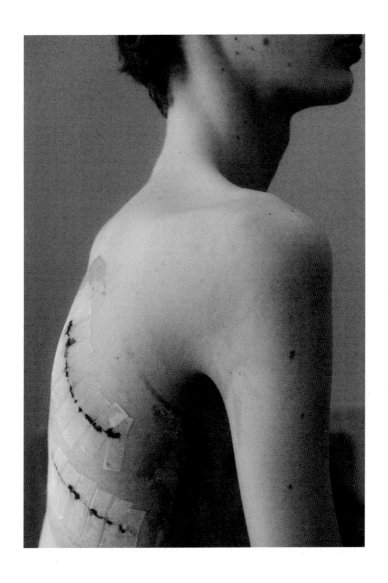

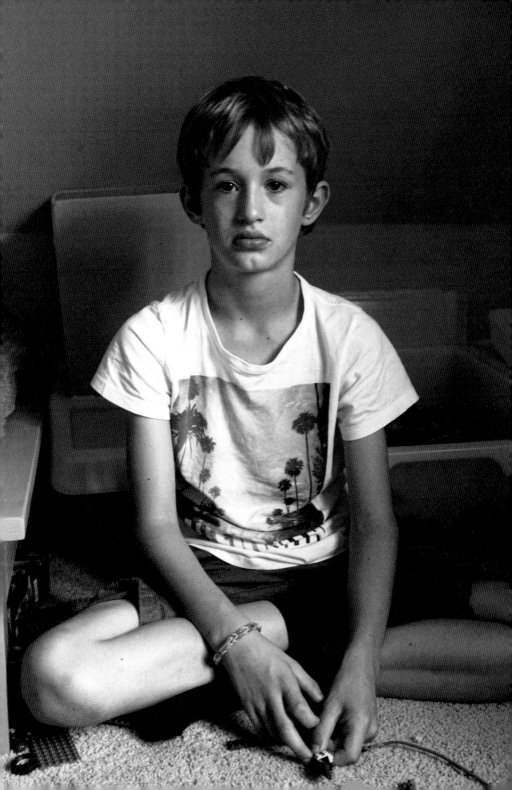

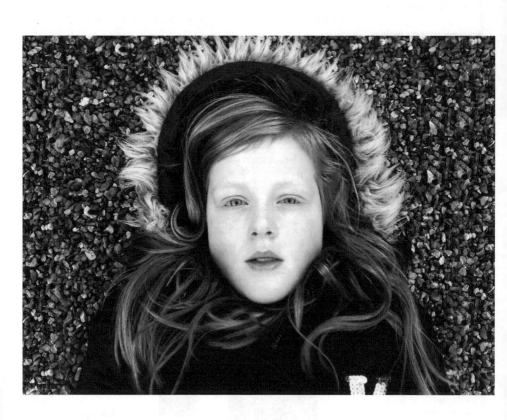

Courtesy of the author

THESE STOLEN TWINS

Viktoria Lloyd-Barlow

L ike many autistic people, I find neurotypical communication fascinating but often deficient in fixedness. Since childhood I have examined ostensibly arbitrary conversation for repeated patterns, and my social ability has been informed largely by what I have discovered. The principle I find easiest to neglect is that dialogue with new acquaintances must be comprised exclusively of topics relating to the participants themselves. Following this theory, though, naturally prohibits any discussion of my central interests, all of which are typically perceived as obscure. An intense preoccupation with a singular topic is a common autistic characteristic, and my own all-consuming interests have previously included: Recurring Lyrics in Popular Music, Ponies Native to the British Isles and Welsh Former MP Neil Kinnock (this fascination took me for several years at the age of nine and was supremely unhelpful in peer interaction). The singular issue I have been most keen to discuss in recent years, whether in a supermarket queue, at a wedding or a children's birthday party, is Local Identity and Geographical Resettlement Patterns of the First Italian Diaspora. I can regretfully confirm that this is not a subject which promotes conversation.

Discourse between recent acquaintances usually favours domestic subjects, such as childhood location and family structure: *Where*

did you grow up? Do you have siblings? How many? Most informal conversation runs on such limited and predetermined themes; the resulting queries are not requests for facts but an invitation to tell charming stories. Social interaction adheres to a collective rhythm as strictly and imperceptibly as an orchestra whose members look at each other and rarely at the musical score. Each speaker follows the orderly prettiness of whatever piece is played, and this with an artlessness contrived to disguise their performance. The conductor, who in conversation directs the questions, will be poised to share carefully crafted stories of their own early years; these will usually be far more melodic and picturesque than the truth. For me, the happiest element of such dialogue is this practice of telling acceptable stories, rather than relaying facts, because my sibling experience is as unstable as it is unsayable. If conversation were not music or stories but only truth, I would be obliged instead to share that I have more brothers and sisters than I can count or name, that I am one of six siblings and my favourite is dead, that I now have just two beloved brothers, and each of these is a twin only to me. There have been too many brothers and sisters in my life to accurately name or remember. Who would I treacherously forget if I tried to number them? Other families have a static and knowable cast. My own siblings cannot be counted, but only flicker at the edge of my memories, their identities as uncertain and shifting as water.

Fortunately, creativity was the first principle of conversation I learned. It was a pledge made by all the children in my home; *Outside this house, we speak only of stories that will not disturb either the listener or the cadence of our shared song.* This was the only rule observed by our disparate tribe, who had all been close enough to violence to know the dirty breath of it on our skin. It was the innumerable siblings themselves, those tiny and tyrannical rulers of my childhood universe, who taught me that stories or silence are safer, always, than disclosure. They trained me to creatively employ narrative as a tactic of evasion as much as one of entertainment. And, when I had no story with which to shield our unpleasant truths,

I turned instead to the muteness which was my regular preference. I was usually the youngest sibling, and always one of many; my characteristic silence was welcomed rather than recognised as another of my autistic traits.

M y parents married in the early 1970s and moved to an industrial town in the Swale district of Kent. They eventually had six biological children, of whom I was the last. My mother worked as a foster carer and raised us as siblings to the looked-after infants and teenagers who moved through our home over the course of almost two decades. In our household there was no distinction of feeling between those who were biologically related and those who were simply instructed to regard each other as such. Indeed, of the two siblings I love best, only one is genetically related to me. He is the twin brother who took his last breath when I took my first, as if he had been waiting to greet me but found there was enough air for only one of us. Born before me and at a sturdier weight, he should have survived. I imagine he met death as defiant and open-mouthed as a caught, shining fish, refusing to cede. He is the sibling I think of most fondly and most of all. My other favoured brother is the baby who came into care after the surgical removal of a nappy left to rot into his skin by his mentally unwell parent. He was placed with my family days after I was born and instantly became my other twin. Three years later he was sent to another foster carer, but he remains the dark-eyed face of my earliest memories, my second stolen brother.

Like each of my twin brothers, the various siblings we were assigned departed abruptly and without preparation or explanation. They lived with us sometimes for days, sometimes for years. There was never a fixed period of stay. The names and faces of these temporary siblings changed often, but my family was always in double figures and our house always chaotic. The children fostered as our siblings were those who were difficult to place in other family homes. Their behaviour was the result of significant previous trauma, which typically included physical abuse. The particulars of these

horrific events, when relayed, were disturbing, yet also desensitising in the manner of a toxic exposure therapy. I came to believe such practices would inevitably happen to us all in our turn, that every young person eventually suffered these as a matter of course.

Our mother was impressively unflinching in the face of hostility and violence, and this fortitude was essential to her vocation. My oldest biological sister, who, in a pleasing symmetry, is eighteen years younger than our mother and eighteen years older than me, was similarly resolute. She and our mother sometimes reminisced with the proud and studied nonchalance of former soldiers: *Remember the girl who locked herself in the toilet with the baby and a knife?* my eldest sister would say, as our mother laughed. Or one of them might ask the other, variously, *Who was it that stole the television/the dinner money/the Christmas presents that time?* Each of them would frown identically as they tried to remember names, to separate one minor emergency from another. Their recollections were never accusatory or condemning but were shared with the fond amusement others might reserve for more routine familial missteps, those that do not involve violence, drugs or pregnant fourteen-year-olds.

The practices of our own home naturally resembled those found in institutional settings. Money, sentimental items and anything that could be easily sold was optimistically hidden or secured. Bedrooms were allocated and arranged according to gender and the number of beds that would fit into the space – looked-after children were not required to have their own bedrooms at this time, as they are now. Bunk beds and camp beds were lined up so closely that it was impossible to get up without climbing over or disturbing at least one room-mate. We were occasionally woken in the night by an emergency placement in our already crowded room. Hot food was served in multiple sittings because there were too many of us to fit around the table at once. The lengthy preparation of these event-sized dinners might be interrupted by a threatened suicide or a physical fight, an update on a missing child, or the need to telephone for immediate police assistance. And after solving these sibling crises, our mother

would return to the small kitchen and continue her domestic routine without comment, apparently unmoved. We only knew about such incidents if we witnessed them ourselves; unruly brothers and sisters were not remarkable enough to invite familial review afterwards.

Luke and Andrew were biological brothers who became my foster brothers for almost a year when I was twelve.[1] They came into care after being trafficked and sexually exploited for several years. Andrew was fourteen, and occasionally he overlooked the fact that we had all been designated as siblings and went into the girls' bedroom completely naked. If he discovered you in a room alone, it was much worse. There was a long-standing brother who helped Andrew by cheerfully holding the door closed against the girls within. Andrew's biological brother sternly forbade the unwelcome visits when he discovered them. At sixteen, Luke was extremely handsome, and extremely violent too. His rages came as randomly and unprovoked as weather. Once, without comment, he presented me with a heart locket on a delicate chain. He did not tell me where he got the necklace from, and I never asked. I wore it faithfully. One of Luke's episodes involved throwing furniture, a door and a family pet from the first-floor landing while describing what he would do when he finished there and came downstairs. Policemen managed to climb up between falling pieces of wood and detritus, but it took several of them to restrain him in his fury.

My siblings and I did not remark directly on such incidents. We were little fatalists, as superstitious as primitive villagers in not naming what we did not wish to conjure. If we acknowledged the menacing forces that circled our home as invisibly as air, they might take shape, possessing any of the children who were amenable to them, as indeed many of us were. When Luke returned home, he was quiet and self-conscious only for the moment it took for one of us to comment that his hair looked stupid or that he had missed dinner and

[1] While all events described here are true, I have changed the names of places and any identifying details.

would now go without. In response to this sort of statement he might throw something at the offending sibling, entirely missing them. We all knew, from experience, that he had a perfect aim. The police were called to our house about Luke so frequently that eventually he was moved into a secure unit. A small number of us visited him there, just once, and we were accompanied constantly by several of the resident staff, as if in a demonstration of protection. *You must be kept safe from this*, said their severe uniforms, their collections of keys and their watchful faces as they marched us down long corridors and through heavy doors to our once-beautiful once-brother. Luke had always been fastidious about his appearance; as a detainee, however, he wore a non-branded tracksuit of a kind he would previously have ridiculed, and the little he spoke was slurred and slow with medication. I did not tell him he had already been replaced at home by a boy of a similar age, one with less fury and no brilliance at all.

The following year, at thirteen, I came home to find a police officer posted at our front porch. Behind him the door was sealed with yellow tape to prevent entry to the crime scene. The key was still visible in the lock. No one had their own key to the house in which my many siblings and I lived. There was always just one key, and this remained in the door, visible from the street, a shining reminder that whoever wanted to enter could do so at any time and without invitation. This did not seem unusual to us. What was there outside that could be worse than what was already in the house? I thought an astute passer-by might, in fact, use the supplied key to lock us all in and thus make the outside safer. We knew already that Bad Things happened inside homes, and especially those in which we lived. The police officer would not explain what had happened and sent me next door. Our neighbour was a kind man, with a wife and four friendly children. They did not live as we did, but in a considered way, with an endless supply of fruit juice in their fridge and a glossy piano in their hallway. He told me that my mother was in a coma, and it was not yet clear whether she could survive. Of course, I already

knew who was responsible, and I knew, too, what weapon would have been used because he carried it around like an accessory. My father was a showy kind of executor and had always boasted about finishing with a scene exactly like this.

Over the next few hours various siblings appeared, one by one, in the room where I waited. Several of them no longer lived at home and must have been informed by someone else. The neighbour told his terrible story again to each new arrival. He always made the same introduction; *I am afraid something very bad has happened . . .* and he used the same words and pauses with each retelling, as though following a script. Faraway and frozen as I was in my own perfect silence, I imagined the ways in which this man might afterwards describe the scene and himself within it to his own sweet-faced family, once my siblings and I had all been taken away.

The whereabouts, occupations and lives of my brothers and sisters are entirely unknown to me now, as mine are to them. After my father went to prison, we moved house frequently, and at least five of us changed our shared last name. I believed, then, that his absence would transform our family into a closer group. I had always involuntarily conjured a dozen queries for every stranger I passed and even more for the people I knew; the questions came as compulsively as a tic. The person who had most despised and condemned my interrogative style of speech was finally gone. My remaining family were another human puzzle that I hoped to finally solve through questioning. I was yet to discover that, just like my father, they would not allow such talk. They would smile while they silenced my questions, for their ways were subtler and more sophisticated than his. But they were already trained as his accomplices, and were equally set on shaming me.

In our household of people, I was always the youngest, and this by a considerable distance. Throughout my childhood, my father had expressed his unhappiness physically, throwing me across our front room with one hand and the easy grace of a bowler, as though I were

nothing. When I was six or seven, he did this in a caravan while the rain beat down above us all. The papery walls were so much softer than those of our house that even as I landed against them, they felt alive with gentle sorrow. My father, large and inexpressive, was such a cliché of a domestic villain he could not have acceptably featured in good fiction. Somehow, he managed to remain tedious even while terrifying, and throughout his wildest furies. As a memory, he is less puzzling and problematic than the various blank-faced but beloved family spectators who only looked on. It was many years after his incarceration that I finally asked two female relatives what they had thought about watching me regularly thrown at the walls of our home. This pair had been among those onlookers who were adults and not children. I practised the question alone first, as I typically did with such queries, to ensure it was free from accusation: my father had actively preferred an audience and that was not the fault of any bystander, whatever their age or status in the group. The first responded, *Well, you were very, you were very sort of . . .* and then fell quiet, looking at the other as if they both knew a secret. The second woman said, *Whiny! Oh, she was a whiny child. And sulky too.* And the first agreed, with a grateful laugh, *God, wasn't she though? Wasn't she?* All attempts to discuss my childhood were, like this, symbolic re-enactments of my father and the wall. In his absence, it was only my words fluttering across the room as though they were nothing. And the family walls with which they collided were no longer made of brick, but something more brutal.

I do not make a good sister as an adult any more than I did as a child. I remain aloof and exhaustingly private. I live with the family I made for myself in a peaceful home with a locked front door, and my days are quietly peopled only by those I choose. Today I am a sibling simply in spirit, and this solely to the two beloved boys who are not brothers to one another, but only to me, their twin sister. They are startlingly different from one another in appearance, these stolen twins. The pale-haired one looks like a boy made only of me, and the other is unlike either of us, but is sharp-featured and dark-eyed.

I do not believe these lost siblings would have joined in to watch, with mild interest, as my father demonstrated the ways in which he could silence his youngest child. When asked what they thought about such a man, they would not laugh together conspiratorially and list my many unappealing traits. If you ever find yourself in conversation with me, though, somewhere noisy and overheard by strangers, do not expect to hear about any of this when you ask me about brothers and sisters, because I will tenderly tell you a different story instead. It will be shaped into something you can tolerate; there will be nothing to disturb you, and no truth in it at all. ■

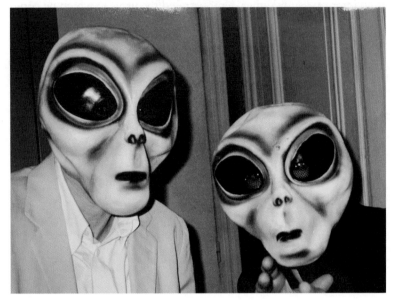

Paris, 1999

For a year, my older brother and I lived around the corner from each other in the 11th arrondissement. He was already a long-term resident; I was there because one day, at home in Dublin, I realised I *could* be, and if could, should. Most Friday nights we went down to the Bastille, bought two bottles of Veuve Clicquot from the same little store, and walked up the rue Saint-Antoine to a flat mysteriously owned by our friend Marcie, a beautiful South African woman who made a precarious living recording the English-language announcements for the Gare du Nord.

Friday nights at Marcie's was the weekly 'po': a party for ten or fifteen people, depending on who was in town. Most of the action was in the sitting room overlooking the courtyard. It was a small room – like many Parisian apartments most of the flat was corridor – but big

enough, just, to dance in, get high, dance some more. My brother adores a party. He takes parties personally. He has a gift for them. He will, as a general rule, be the first onto the table. He consumes like a Viking, or he used to. His appetites were one of the things I most admired about him. I wrote a bad poem once juxtaposing our characters, in which I was 'the monkish younger brother'. This was something of a misrepresentation, as I was rarely more than a couple of drinks behind him and in my teens was a reckless and enthusiastic pill popper. By Paris I'd slowed down. Or perhaps it was simply that the role of roisterer was spoken for. Isn't that how it goes? The parts cannot be duplicated. If one brother is practical the other must be fingers and thumbs. If one is quick the other must be slow. If one performs the other watches.

Whatever he took on board, however heroic the measures, I never knew him not to remain witty and good-tempered, though there were two or three times when I was aware of him having breached some border of the known self (known to him, known to me) becoming, in a way that was slightly unsettling, somebody else, less predictable. And while he was filling his glass or woofing powder up his nose I might be found in a cramped corner by the window having a conversation too serious for the occasion. If he spotted me he would sound my name like a hunting cry. I loved that because I never wanted to feel forgotten by him. I'd rouse myself, we would tap glasses, and I would feel the infectiousness of the pleasure he was getting from doing more or less exactly what he had done the Friday before. We would, for a while, resume our old double act, talk nonsense to each other, cod Elizabethan, Rosencrantz and Guildenstern. I might, in this new mood, start to dance. I might, if he reached down a hand, climb onto the table with him.

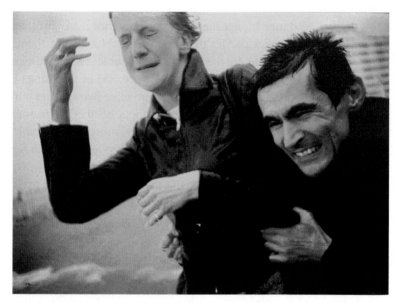

Brighton seafront, 2002

I had just moved down to Brighton, delighted to have escaped London and the claustrophobia I felt there. I'd bought a flat on Adelaide Crescent and we were having a gathering of the type that hadn't happened much since our parents died. It was autumn; the wind lifted the sea, the rain was horizontal, though the day was strangely warm. My brother took the photograph, and I like how I seem to be supporting my sister, helping her to brace against the wind, as a brother should. I have, over the years, not done a great deal of supporting – not a great deal here meaning not enough.

She is seven years younger than me, ten years younger than my brother. She is my half-sister, her father my stepfather. When the rest of us left home she was still there, a young teenager with parents who had, perhaps, grown weary of parenting. She tells funny stories

about that time that are not quite so funny when you think back on them. At some point in those years she acquired an unhappiness it has taken her decades to unravel. She is a gentle and humorous woman, sensitive to a degree that has often proved unhelpful to her. One could find, with no difficulty, a full jury of friends to speak of her intelligence, her kindness, but in some Star Chamber in the depths of her being she still, I fear, routinely condemns herself as a failure.

Certain things were supposed to happen. There was, for example, meant to be a big wedding in Bath Abbey, a grand affair that might get its picture in the local paper. Instead, she is unmarried and has no children. There was a period of addictions. At one time she had her dealer – a Serbian who drove around the West End in a kind of mobile drug supermarket – on one-button dialling. There was vodka, a small ocean of it. (We are a drinking family; our mother in her last illness knocked back glasses of gin and Lucozade.)

You fly through your twenties, go a little slower in your thirties. After forty it's anyone's guess. She became (to her horror) someone the family was officially worried about. At her lowest point I wondered how interested she was in surviving. There was a crisis; by sheer luck she was found. From that moment she began her fightback. A decision on its own is not enough, but without it you have nothing. She works now as a psychotherapist in a London prison, worked all through Covid. She is entirely unassuming. I do not see her often enough, but on the phone she sounds cheerful, strong. With or without a brother to hold her, she seems to have weathered the storm.

Essex garden, 1965

There's a collection of photographs of us as young boys that my brother calls the 'out-of-focus childhood series'. He found them for me when I told him I was writing this. I had seen some of them, not all. When parents die their effects are parcelled out according to a certain logic. The photographer gets the photographs. I, the writer in the family, was given a desk.

The pictures in the out-of-focus series were taken by our grandfather, who most people knew as 'Sonny'. Cameras were more intricate in the early 1960s; the amateur of photography had to be capable of something more ambitious than pointing and pressing a button. Sonny, in fairness, did a reasonable job, but my brother, whose career as a photographer has straddled the analogue and the digital, suggests that he had an unsolved problem with the infinity setting.

I don't remember having seen the picture of us in the garden

with grandma before. This is Granny Frieda, who I named my daughter after. We are all dressed up, but for what? Granny herself looks delicious, as if sculpted out of marzipan. My brother, who is clearly not enjoying the photo opportunity (though in adult life he has become an adept at meeting the camera's eye, knowing better than the rest of us the character of its gaze) is dressed in what is presumably his primary school uniform. The handkerchief in the top pocket – whose idea was that? He looks as if he'd rather be kicking a ball around. He was good at football.

What I look like, what I have been dressed to look like, is anyone's guess. Perhaps for an audition to join a troupe of itinerant balalaika players. I have some faint, vestigial, physical memory of those sandals, the shine and touch of the buckles. I seem pleased enough, though it may just be I was happy to be holding Granny's hand. When I was a baby and my brother a toddler, our mother was taken sick in the night and disappeared from our lives for many months. It was Granny Frieda who cared for us then. When my mother came back she said I looked at her blankly. She was a stranger.

I note that my brother – he'll deny it but he was always the moody one – has apparently refused to take Granny's hand. He is, as a result, being held in a manner that suggests an element of restraint, the way Dixon of Dock Green might have returned some errant youth to his parents' house ('I think he's learnt his lesson now, Mrs Jones').

Light falls sweetly onto the world behind us. A clipped hedge, rose bushes in bud. Late spring, call it May. Granny Frieda wears pearls that later our mother would wear, that now our sister wears, that one day my daughter will wear. She was a tough Northumbrian from farming stock. A drystone wall of a woman. She had been on her own through most of the war with two young girls and a slew of evacuees. If Sonny doesn't sort out the settings on his lens in the next few seconds I think she's going to say something. Everyone's been waiting long enough. ■

The house of my childhood was thickly haunted, so we spent what time we could outdoors. This is where, I believe, the rite came from, a way to mark our joy at being released from the house's chill and eerie confinement and set loose into the warming spring. My brother now says the rite was not a rite, that it was only a fluke that happened once, as a bet; my sister, the diplomat and wise one, says she doesn't remember, but that of course truth is a shifty thing, dependent on the needs of the rememberer.

I need to believe that our family's weird little rite happened every year. It was always still April, and the ice had thawed and new buds were on the trees, and in the forests that ringed our lake there were still hollows of snow gently melting. We waited until dusk on the appointed day, then came out shivering in our bathing suits and stood beside the winter-covered pool. I remember solemnity over a sense of barely held glee.

My father had us peel back the pool's heavy black cover on which autumn leaves had melted into a brown slurry, and heave it to the deep end under the diving board. By spring, the water would be viscous and dark with algae and the disintegrated bodies of dead creatures, which we sensed there even if the water was too thick to see them. Later, after the pool was shocked with chlorine, after the release of the slime-eating robot, we'd find the skeletons of frogs in the gutters, tarry clumps of feathers that used to be birds.

The game was simple: The winner would be the child who could stay in the freshly uncovered water of the pool the longest. The prize was a dollar. In the 1980s, a dollar would have bought four cake doughnuts at the bakery on the corner of Main Street and Chestnut, or one enormous jawbreaker from the candy store that we'd lick into rainbows for months.

At the signal, we descended the steps into the searing black cold. My father was a doctor, and would pace on the deck to make sure the competition didn't kill us. We must have all been under ten years

of age, but the odds were stacked along the lines of personality. My brother is sixteen months older than I am and has always been brilliant, funny, loud, insistent. Any experienced bettor would have put their money on him to win. My sister is twenty-eight months younger than I am and has always been the baby, the one person in the family who is unreservedly beloved by everyone, because she is the kindest and gentlest. Even now, she is the one who makes all the birthday cakes and who counsels us in our sorrows. Nobody would have thought, looking at her, that she'd have made it to even ten seconds before caving. On those strange nights, it was every kid for themself. Those with the most bravado might splash the others, until splashing became too cruel or we could no longer control our limbs. Then we went deep into our own suffering, avoiding eye contact and shuddering until our lips turned blue.

My memory tells me that I always won. I outlasted my sister, who was so young and tender, and hadn't yet come into the full flower of her competitiveness. I outlasted my brother who was surely smart enough to grok the stupidity of the game, that the winner was in fact the most obvious loser. Whether or not my memory is telling me the truth, it tracks. I would rather have died of hypothermia than let my siblings win. I think we would all agree that I still would. ∎

Found photograph
Courtesy of the author

RAY & HER SISTERS

Sara Baume

Norah and Reginald meet at a tennis club in east London during the Great War. Reginald has an elegant backswing. Norah has a powerful serve. They play doubles. They play each other. They strike up a romance and get married. Reginald is a clerk in the Westminster Bank. He has a horsey face, long and sad, with spectacles. He is anxious by disposition. Norah is bossy. She has a swarthy complexion and volunteers for the National Relief Fund. She comes from a family who bettered themselves and lives in a house with three floors and two maids who sleep in the attic.

Reginald buys a large house in Blackheath with the help of Norah's father. Beryl is born first, and then Ray in 1921, three years later. She is going to be named Pamela, but after she's born she does not seem like a Pamela and so they name her after an uncle, Captain Wray, who was killed in Gallipoli. Ray contracts polio when she is a few months old. She is not too sick but her right leg is damaged and a physiotherapist called Miss Gedge visits once a week to do exercises with baby Ray on the billiard table. When she is two, Barbara is born. Ray's earliest memory is of baby Barbara in her treasure cot. It has pearly white sides, a lacy canopy and trailing silk ribbons. It rocks gently on the floorboards of the nursery as Ray peers inside.

Barbara is her mother's favourite. She is a timid child who carries her toy farm animals everywhere she goes, stuffed into the pockets of her cardigan. Ray is her father's favourite. She is short-sighted, like him, and studious. Ray and Barbara are natural comrades, united by their fear of Beryl, who is stubborn and imperious. Beryl is nobody's favourite, but she is the most beautiful of the sisters. She has her father's height and her mother's aristocratic features. Reginald is promoted to bank manager. He buys an old Crossley motor car and every summer they go on their holidays to Birchington-on-Sea. Norah is the driver; Reginald navigates. They always argue on the way. Norah knits beige bathing suits for her daughters and Reginald rigs up a curtain that can be pulled around all the windows of the car to hide them from sight while they are changing. Ray loves the sea – the sweeping strand, the smell of salt and weed, the vacillating tides.

Ray, Barbara and Beryl, c. 1926

Ray is the only sister to win a scholarship to boarding school. Norah drives her down to Sussex with a small trunk of necessary possessions. Barbara waves ferociously out the rear windscreen of the car as it heads back to London. Ray is lonely at first and teased for being a scholarship girl. When her parents come for day visits she is

embarrassed that they pack a picnic lunch instead of taking her out to a hotel. Beryl leaves school early. Reginald gets her a job in the income tax section of the bank and in her spare time she does in-house modelling jobs for a ladies' clothing boutique. During the holidays Ray and Barbara dance to the gramophone in the dining room and play tennis at the club where their parents met, eyeing up the young men. By the time Ray is a senior her best friend is an Irish girl called Lana. In the evenings they play cribbage and Monopoly with the other senior girls in the common room. On the night that Edward VIII abdicates, they are allowed to gather around the wireless. Ray doesn't approve, though she thinks Mrs Simpson is very chic.

At elevenses on Sunday the 3rd of September, 1939, Neville Chamberlain declares that England is at war. Air raid sirens sound across London immediately, and everybody scrambles for shelter, but there are no bombs. There are no bombs for almost a year. Beryl and Ray learn to drive and volunteer with the Young Women's Christian Association to transport mobile canteens around the city. Hundreds of Zeppelins appear suspended in the sky over London, tethered to steel cables manned by members of the RAF's barrage balloon squadrons who live in huts on-site. The canteens contain tea urns and currant buns and Woodbine cigarettes. Ray likes to prop the window open and lean out to chat to the men as they take their breaks.

Men are becoming scarce. The sisters are allowed to have their friends and boyfriends around for afternoon tea at the weekends and they play 'sardines' in the rooms of the rambling house, kissing in cluttered wardrobes. Barbara finishes school and follows Beryl into the bank and falls in love with a golden-haired Royal Engineer called Keith. Ray gets engaged to Ralph, who has a claw hand and a little green sports car that he drives too fast. On Christmas Day in 1940 he crashes into a delivery van on the way back from lunch in Blackheath. Ralph breaks his nose against the steering wheel but Ray, who is in the passenger seat, is flung through the windscreen and lands in shrubbery on the

side of the road. Barbara and Keith ride with her in the ambulance. Barbara holds Ray's hand and Keith holds Barbara's hand. Ray is unconscious for three days. When she wakes up she finds that her two front teeth are missing and Ralph has broken off their engagement.

By then bombs are normal. When the air raid sirens sound the nurses on Ray's hospital ward distribute enamel washbowls and push all the beds into the middle of the floor to make an island. Then the patients put their pillows over their heads, and the washbowls over their pillows, and the nurses clamber underneath the island of beds. Somebody tells Ray that if you can hear a bomb falling then it will not hit you, and so she tries to be comforted by this.

Ralph's mother feels bad about her son's behaviour and invites Ray to convalesce at their house in Hampshire, safe from the London bombs. Ray spends six awkward weeks in the wintery countryside. She sits up in bed looking out at a bare sweet chestnut tree and reading novels, *Gone with the Wind*, *Tender Is the Night* and *Cold Comfort Farm*. Every now and again a piece of her splintered jaw surfaces somewhere in her mouth and she spits it out like an apple pip. Spring finally comes and Norah arrives in the old Crossley to collect her daughter. Then she forces Ray to drive all the way back to Blackheath, so that she will not be afraid.

Barbara marries Keith in 1943. She wears a dress borrowed from one of her friends in the bank. They have soused herring for their wedding dinner. Then Keith is sent to Normandy to clear landmines. Beryl and Ray volunteer to join the Women's Royal Naval Service and are posted to Dover to become motor transport drivers. Beryl, who has a habit of impressing her superior officers, is chosen to be the admiral's personal driver. She becomes solely responsible for his silver Rolls-Royce, whereas Ray is assigned a new vehicle every week. In Dover Ray drives trucks delivering supplies, and ambulances collecting casualties from troop ships, and cars escorting the family

members of soldiers who have been killed. After two years both sisters are promoted. Beryl, tired of the officers who insist on sitting in the front seat of the Rolls-Royce and stroking her left knee while she is driving, goes into the administration department and Ray, who fancies herself a spy, goes into the intelligence service. They have just finished general training and are waiting to be posted when they hear that Reginald is ill.

Barbara, Norah, Beryl and Ray, c. 1938

Reginald has retired from the bank and is staying with his sister in Chester when he is diagnosed with a duodenal ulcer. He is admitted to the local cottage hospital for a simple operation. The doctor gases him to sleep and he never wakes up again. In the same week Barbara receives a telegram to say that Keith has been wounded and is in hospital in Basingstoke. He has a leg injury and a fractured skull. Barbara finds him sitting up in bed with a huge, white bandage wrapped around the golden hair on his head.

In the intelligence service Ray is posted to the Shetland Islands. She is astonished by the beauty of the bleak scenery, the grey stone buildings, the omnipresence of the sea. Ray searches for spies and attempts to intercept German codes. She assists with the testing of human torpedoes and operations that involve sending midget

submarines to the fjords of Norway to surreptitiously attach limpet bombs to the hulls of enemy battleships. In the last year of the war Ray is recruited to Lord Mountbatten's staff and posted to Ceylon. She spends four exciting but uncomfortable weeks on a converted merchant ship. It travels down the Suez Canal and through the Red Sea. It is so hot and squashy that Ray carries her mattress up to the top deck at night and stretches out between the funnels. The ship has almost arrived in Colombo when news of the Hiroshima bomb reaches them. By the time they dock, the war is over.

In Ceylon the Women's Royal Naval Service officers wear white cotton uniforms and sleep beneath mosquito nets in rooms with walls that don't reach all the way to the ceiling. At night they hear jackals prowling outside. After five years of war, it feels like a holiday. Ray goes swimming and eats pineapples and smokes Lucky Strikes with the Americans. After three months she is sent to Singapore in a Sunderland flying boat.

Back in London Beryl is promoted to first officer. She has grown stocky and learned to sew. She is allowed to stay in the WRNS, whereas Ray only ever makes third officer before she is demobilised. When she finally arrives home she thinks she has a very fine tan. Barbara gives her a hug and declares that the colour of her skin is, in fact, mustard yellow, which turns out to be a side effect of the antimalarial tablets. In 1945 Barbara opens a toy shop in Blackheath called Raggity Ann's. It sells high-quality wooden toys, porcelain dolls and model plane kits. The shrapnel is still lodged inside Keith's skull, and he limps. They have a Sealyham terrier called Sam Small.

Ray finds it hard to adjust to being a civilian again. The regal city of her birth is in ruins. The thrilling pace of her adult life has halted. She manages to get a job with the British Travel Association but after three dull years she gives it up and starts training to become a nurse. Ray is twenty-eight and all the other trainees are nineteen. They wear

butterfly caps and long, striped dresses. They scrub floors, empty bedpans, dress wounds. Ray loves the warm glow of the ward at night – its radiantly white bed sheets against the dark blue of the sky through the naked windows.

During the holidays Ray visits her old friend Lana in Ireland. Lana lives with her family in Clydaville – a formidable country house by a river. Ray takes the boat to Dublin and Lana's fiancé, Frank, picks her up at the port. Frank is tall and erudite and charming. During the lengthy dinners at Clydaville he seats himself opposite Ray and shoots sultry looks across the tablecloth beneath the gauzy light of the paraffin lamp. Then one day Lana meets a young medical student on the train, falls in love, and breaks off her engagement. The next time Ray arrives in Dublin port, Frank is waiting for her. He takes her to dinner. She laughs at the way he pronounces the word 'butter'. He laughs at the way she pronounces the word 'police'. Lana did not want him anyway.

Norah does not trust Frank, because he is Irish. And Frank's mother does not trust Ray, because she is English, and a year older than him, and godless. Barbara thinks Frank is devastatingly handsome and Beryl warns Ray off good-looking men, but they get engaged anyway. Frank has Lana's ring recast and Ray gives her notice to the hospital. Then she goes to the Catholic church in Blackheath to start her instruction. Ray likes the incense and the ritual. She finds that the scriptures make sense to her and the prayer fills a space in her life that she had not noticed. The wedding takes place in May, 1952. Ray wears a white satin dress handmade by Beryl. It has long sleeves and tens of tiny pearl buttons. Beryl is her bridesmaid and Barbara is her maid of honour and Anna, Barbara's baby daughter, wears a fluffy angora bolero and carries a posy. Afterwards they have finger food in Norah's garden. It's a halcyon day and the pear tree is bursting with light. Ray exchanges her veil for a jaunty red hat with a black ribbon and sets off on her honeymoon. She is still a virgin on her wedding night.

Frank works as a businessman with the Irish Export Board. For the first year of their marriage he is stationed in Dublin and they live on the first floor of a Georgian terrace. Frank doesn't have a bank account and keeps all of his money rolled up in a Chesterfield tobacco tin. He peels off £5 a week and gives it to Ray for the housekeeping. Ray is dreadfully homesick. She learns to cook. She goes to Mass every morning just for company. There is an artist who lives in the basement flat and on sunny afternoons Ray watches him for hours, working at his easel in the garden.

Ray falls pregnant and Frank gets posted to New York. They travel first class for five days on a luxury liner. It's stormy and Ray experiences seasickness; watching Frank trying to swim lengths of the pool on the bottom deck, the water inside sloshing and slapping against the tiles with the heave of the water outside. They live in a duplex in Jamaica, Queens. Ray is impressed by the buildings in Manhattan but repulsed by the food. She gives birth to her first daughter, Deborah, in 1953. The doctor administers an anaesthetic, slices through her pelvic floor and yanks the baby out. Deborah is skinny and squally and Ray has no idea how to keep her alive. She is already thirty-two, an abnormally old mother. Her second baby is born in 1955. Ray spends two lonely years in New York and comes home with two daughters.

Frank's next posting is London. Beryl is based on the Isle of Wight and Norah is living with her, and so Ray and her family move into the vacant house in Blackheath. Norah has added a little aviary to the garden, with goldfinches, redpolls and green budgerigars. She has stipulated that all three sisters will inherit the house but Beryl, the spinster, must be allowed to live in it for as long as she wishes. Ray is happy in London but after two years Frank is posted back to Dublin. Frank, as it turns out, has a superiority complex and a volatile temper. He is always the one to decide which plays and films they go to see. He tells Ray what books she should read and never asks for her opinion after she has finished. He sleeps with other women and

when Ray finds out and threatens to leave him he starts to breathe
strangely; he pretends that he is having a heart attack.

Ray, *c.* 1952

Back in Dublin Ray and Frank buy their first house and have their
only son, and five years later, their final daughter. After her fourth
child Ray has a problem with her fallopian tubes and the doctors
decide to perform a hysterectomy. In her mid-forties Ray experiences
an early menopause and just as she is getting better, Norah dies. Ray
travels to London to be with her sisters. They talk about burying
Norah in Chester with Reginald but it is too complicated, and
so she is cremated, and because they cannot agree on a place to
scatter her ashes they scatter Norah right there in the gardens of the
crematorium.

Back in Ireland Frank becomes a chief executive and buys a holiday
home for his family down on the south coast. The house has a rangy
front lawn that runs down to a pebble beach and a pier that can be
dived off at high tide. On the last day of the school term Ray packs up
her Mini Cooper and straps four bicycles to the roof and waits outside
the school gates for the final bell. Frank spends the weekends with his
wife and the weekdays with his girlfriends in Dublin. Ray loves the
sea. She establishes a rockery and a strawberry patch. The holiday

home feels like a consolation for all the lonely years of marriage. She is there, sitting on a rug on the sea-facing lawn with a book and a battery radio, on the morning she hears that Lord Mountbatten and his wooden boat have been blown up by the IRA.

In the seventies Barbara and Keith open a second shop in Blackheath selling silk lingerie and French perfume. It's the first boutique in London to stock G-strings. Barbara has become the glamorous sister. She wears fashionable clothes and paints her fingernails and has a sherry at lunchtime in the roof garden with Keith, who is now completely bald. Ray visits her sisters at least twice a year and at least once a year Beryl crosses on the boat to Ireland in her car, a tangerine MG Midget, with Prudence the sausage dog in the passenger seat. Prudence wears a diamond collar and has a skin condition that requires her to be dabbed with TCP. Sometimes Deborah visits London and stays with her spinster aunt in the large house with the rickety aviary. Beryl eats porridge for breakfast every morning but when her niece comes to stay she buys a variety pack and serves it with soft brown sugar in spite of the fact that she has always been disapproving of Ray's children; because there are so many of them; because they are Irish. Beryl retires a decade before the WRNS are subsumed into a force that no longer separates the women from the men. She goes on cruises to far-flung places and has very long hair that she wears in a bun. Frank jokes that she will leave all her money either to the Conservative Party or the Battersea Dogs Home.

The holiday home, always draughty and creaky, has started to crumble by the early 1980s. Ray and Frank sell up and buy a house nearby in Ballycotton, with spiral stairs and a big concrete balcony and a view of a lighthouse. Ray swims in every season and walks the cliffs each morning with her dog. She has a dog called Gyp, then a dog called Voss, then a dog called Jack. She always chooses mutts. She goes to Mass. She plays tennis. She forms a painting group. They meet every week around the kitchen table if it's raining, or out on the concrete

balcony if it's fine. Sometimes they set up their easels in the garden. They have an exhibition every July in the Cliff's Stop Cafe.

Frank dies in Ballycotton in 1991. It's January and he has just returned from a walk along the cliffs where he was hunting for early primroses. He collapses on the parquet floor of the kitchen and has a real heart attack. Ray and her children buy a double plot in the local graveyard and plant Frank there, with primroses on top. Keith dies three years later. Ray flies to Blackheath for the funeral and the sisters sit together in the roof garden and sift through black-and-white photographs, reminding each other of the colours they lack: the pink of Sam Small's pendant tongue, the cheerless olive green of Keith's Royal Engineers uniform, the gold of his hair.

The sisters are in their seventies now. Ray and Barbara are grandmothers. Ray has a prominent dowager's hump. She wears tweed skirts and tracksuit jumpers and finally applies to go to university. She does a short course in Women's Studies, then she starts a degree in English and History. She buys a laptop and learns how to use it. She graduates when she is eighty-four. All of her children attend the ceremony and take pictures of their mother in her gown and mortar board to send to Barbara. Ray doesn't travel to London any more but she talks to her little sister every week on the phone and they exchange news of their big sister, who has grown even more cantankerous. Ray and Barbara try to convince Beryl to move out of the large house in Blackheath so that they can finally share their inheritance, but she will not budge.

Ray starts to research for her master's degree. She gets up early every morning, walks her dog, goes to Mass and then to the city archives. Deborah and her granddaughters visit every Sunday for afternoon tea. They talk about novels over egg sandwiches and Fox's Classic biscuits. Ray is happy. Her only remaining wish is that she will not lose her mind and be a burden on her family. In 2007, age

eighty-six, she is diagnosed with oesophageal cancer and dies at home with all her children flanking her bed, keeping vigil. In her final hours Ray floats in and out of consciousness and dreams back through her life in brightly lit scenes. She sees her easel in the garden, a patch of ripe strawberries, the luminous pear tree. She sees the naked windows of the hospital ward, the stars between funnels above the Red Sea, the Zeppelins tethered to steel cables. She sees the sweeping strand at Birchington, the glistering water; she smells the salt and weed.

Death, like the bomb that never hit her, makes no sound. Ray chooses not to be buried alongside Frank, and so she is cremated, and Deborah donates the handwritten notes for her semi-completed thesis to the city archives.

Beryl has a hip operation and finally sells Norah's house in Blackheath and moves into sheltered accommodation. On her final cruise she slips on deck and is airlifted to a hospital in Buenos Aires. She makes it home to England, reaches her ninety-second year and dies of a stroke. Her nieces and nephew are surprised to find that their spinster aunt had not been rich after all. In fact Beryl dies penniless after decades spent sponsoring children in the Horn of Africa through various charitable organisations. Nobody finds out what happened to Prudence's diamond collar.

Barbara misses her sisters, but then she starts to forget. She forgets that Beryl and Ray have died. She forgets that they grew old. She forgets the present, and then the recent past, until all she remembers is the distant past. She remembers the G-strings and the toy shop. She remembers Anna in her angora bolero and Keith holding her hand in the ambulance. She remembers the gramophone in the dining room and the farm animals in all the pockets of her cardigan, and finally, she remembers the pearly white sides of her treasure cot, the lacy canopy and the trailing silk ribbons and the smiling face of her big sister, Ray, peering inside at her. ■

You're the only one left who remembers when an 'artist' came in one day with coloured chalks and drew strange animals straight onto our bedroom wall beside our cots, which we lay in all day long when we had chickenpox or measles and couldn't get up until the fever broke. And our doll's house, which we always squabbled over and could never share. What was yours and what was mine? Whose was whose?

When Mother and Father divorced, it was you who gave your grief free rein while I held mine in check. You were Father's and I was Mother's. So when she consulted me and asked: wouldn't it be best if she and Dad split up?, I just accepted it. I was six. You were five.

We were 'pseudo-twins', only eighteen months between us. I was the oldest, a wartime baby, born when Mother's beloved father – like many other Danish Jews – took the rest of the family to Sweden. She and I had a symbiotic bond. Whereas you came along just after the liberation, like an added bonus, soon forgotten, put away in a drawer. (Had the cradle used for me already been discarded, because Mother didn't want more children?) You were always being sent away, as I recall. To nursery – somewhere I, clingily attached to my mother, had never gone. Later you were sent to boarding school in South India while the rest of the family lived in Ceylon. Two little boys had come along by then, sons looked after by a Sinhalese nanny. You were the only one they sent away, the only one who realised – correctly – that something in our family was wrong. Whomever Mother was married to, she was always crying. And you and me, we only had each other.

In Nærum, on the outskirts of Copenhagen, we swooped through the woods down to the beach on our bikes. (You aren't the only person in the world who's done *that*.) I let you have the top bunk, but always dreamed of a room of my own. I went for walks alone with a book on botany, trying to make myself part of the realm of flowers. I withdrew from the family, aged twelve. Moved down into the basement. I began to write, letting some interpreting entity take over. A demon or a daimon? The twofold gaze of the anthropologist.

This gaze collapsed when we sang together, two voices in harmony. Yours the lighter one, the purer, the first part. Mine deeper, dominant, the second. So precise in phrasing and breath that we were singing with the same air. *Bei mir bist du Schön.*

You idolised me almost like a rock star. You copied everything I did, a devoted fan, imitating my improvisations. And I only wanted to be free. We drew lines everywhere, always: 'You can't come over to my side.'

Father died young, an accident. Burning in his bed. A degenerative spinal condition – he was looking at paralysis, a wheelchair.

Suicide?

Whisky and cigarettes. In bed.

I took responsibility for the funeral – gave the eulogy by the body, booked the musicians: 'When You're Smiling'. An unmarked grave. His friends who gambled and his flamboyant debts: 'Aren't you proud of your dad for owing so much money?'

I don't remember if you were there, at Father's funeral. You'd met your husband, and Father had just about managed to walk you up the aisle, while I was a correspondent in Afghanistan. And I was so relieved because now, at last, you had your own life. What more could I ask?

There was nothing left of Father but charred remains – plus a worn old Burberry raincoat we fought over for ages. All our lives. Even after I gave up the fight and let you have it, to keep the peace.

One day in 1978, after the publication of my third novel, *Crème Fraîche*, your husband rang. He said I could write whatever I wanted, of course, but he – the two of you? – couldn't be around someone who wrote so disrespectfully, especially about you, his wife.

I accepted it. Just as I had accepted Mother and Father's divorce when I was consulted as a child.

Mother had given herself to me. But the price of being 'most

loved' had been high. For years I'd waited on her hand and foot, in and out of psychiatric wards, wiping up the blood when she tried to kill herself. I'd let her stay with me, bought clothes for her and invited her to the Hotel d'Angleterre.

Over the respirator, which I asked the staff to switch off, I sang, 'Now my eye is closing, oh Lord God on high', the hymn she sang with us when we were children. Hearing is the final sense to go.

I think you were there when they switched it off.

And I let you carry the coffin, so you would feel like she was *your* mother too.

I had carried it long enough – by making real her longings and her dreams.

And said nothing at the funeral – for fear of sucking the air out of the room, of drawing attention to myself, of making our mother mine.

Forty years passed. One day on Østerbrogade I'm waiting for a taxi. Suddenly a tall, slim woman comes crossing towards me as the light turns green. She's interesting to look at – a beautiful, aged face, a famous film-star type – Lauren Bacall? She's a woman I would like to know. As she approaches, I realise it's *you*, you who I haven't seen in a lifetime. My sister.

That very second, she sees me: stiffens, freezes.

She ducks into a sports shop behind me.

All at once life is spinning. It lasts a few minutes, a few seconds. And forever.

The taxi doesn't come. I wait in vain. No taxis. I'll have to call again and book another. While she's hiding in the shop, I think: this is it, right *now*, my opening. Should I follow her inside? As I stand there paralysed, buffeted by the wind, that *now* is closing, like the eye Mother used to sing about when we were small and going to sleep. ∎

Translated from the Danish by Caroline Waight

New Year's card made by the author, Beijing, *c.* 1995
Courtesy of the author

SPEAKING BROTHER

Will Harris

'Something vertical when it should
have been sideways.'
– Bhanu Kapil, *Schizophrene*

I don't have a brother; I'm an only child. But a few years ago I started writing poems in which a brother appears.

When I tried to explain what they were, I described them as 'memory exercises'. I had invented a brother to help retrieve memories I thought were lost, or didn't know I had. But the writing took the form of direct addresses ('Brother you . . .'). I was talking to this brother, and talking to him gave shape to events that had grown fuzzy over time. I remembered a cricket jumping into our car on the motorway, a funeral in Portsmouth, eating instant noodles in front of the TV. It was what I imagined having a sibling would be like. We constructed a world together, and sharing this space – whispering secrets at night – made the outside world less frightening.

But I felt guilty. What had begun as an 'exercise' – with all the distance that implies – took on a life of its own. My brother was there and not. Though I spoke to him as if he was real, I refused to give him a name or describe his appearance (if I pictured him at all he looked like me). I felt squeamish thinking about him in any detail. Just as it

feels wrong to imagine the death of a living family member – for fear of tempting fate – it felt wrong to describe the life of a non-living family member. So I left him in limbo.

This way of thinking about my brother – keeping him present and absent – shaded into elegy. He was the listener, the correspondent voice I'd always wanted. But he was silent. I played a Candyman-style game in which I stood in front of the mirror at midnight saying 'brother' to myself. Though nothing happened, speaking as if he was there changed the quality of the silence; it filled it.

In *Siblings: Sex and Violence*, the psychoanalyst Juliet Mitchell writes that 'we all have or expect to have a sister or brother and this is psychically and socially crucial'. It was this expectation that hovered over my early childhood, when my parents considered having another child. The decision was eventually made for them. They worked a lot and didn't know when they'd find the time, then ten years passed and it was too late.

My mum says I used to ask her for a brother. I'd ask her in the way I asked for new toys: 'Can I have a brother, please?' There were siblings all around me – in the playground and on TV – and I must have felt a sense of something missing. But my desire for a brother wasn't as clear-cut as I made out. Like Mitchell suggests, the expectation of a sibling precedes any conscious desire for one. And I think, in asking my mum for a brother, I was picking up on what was already there, testing her, trying to gauge whether or not *she* wanted another child and what that would mean for me. Would a new child change my role at home? Though I had an urge for kinship, I also felt what Mitchell calls 'the fear of annihilation', a fear directly evoked by the prospect of siblings who might replace me.

Mitchell uses 'replace' and 'annihilate' interchangeably. One sounds milder than the other. Replacing a person won't necessarily destroy or annul their existence; most likely they'll go on being, just with the knowledge of their own replaceability. But what replacement entails is a break in perspective. The only child develops a picture of themselves as a subject, irreplaceable in their 'I'-ness, shaping

the world around them. The arrival of a sibling turns them into a replaceable object ('you', 'he', 'they'), one among potentially numerous others. In asking my mum for a brother, I was toggling perspectives, seeing myself as a subject and object, through my eyes and hers, imagining how replacement would feel.

Those perspectival shifts felt normal. Now they make me think of Jacques Lacan's description of the 'fragmented body-mind' experienced by the child during the mirror stage. The mirror stage isn't, as I once believed, when a child recognises themselves in the mirror for the first time; it's when they realise the strangeness of their own reflection in the mirror. Jacqueline Rose writes that 'the mirror image is central to Lacan's account of subjectivity, because its apparent smoothness and totality is a myth.' During the mirror stage, this myth is evident. The child sees that the mirror offers only a partial form of identification. How could that weird figure miming along with you be the same person you feel yourself to be?

I remember a period in my childhood when, after bath time, I would play in front of the mirror. My facial features were like different parts of a puzzle. I'd pinch my nose and suck in my cheeks, wet my hair and give myself a side parting like my dad's. It was around then I started asking my mum about siblings. I could see her in me and me in her. There was something malleable about the face, about family. It was obvious that the person staring back at me wasn't simply 'I': 'he' was an object in the world, over which I had a limited degree of control.

There was a racial aspect to this, manifest back then – I was always playing with my eyes – which became more marked with time. I entered my teens frozen by shame, unable to reconcile the growing dissonance between my subjective experience and the image others saw. My self-image had previously felt fluid and playful; now it was fixed by the assumptions of others. It wasn't just when a barber lectured me about my 'Asian hair', it was in the eyes of strangers everywhere. I stopped looking in the mirror, because I didn't need to: I could see myself in how others saw me.

Lacan says that the mirror stage comes to an end when 'the specular *I* turns into a social *I*'. He gives no sense of how racialisation might distort this process. For him, the 'fragmented body-mind' is transformed into a smoothly socialised self. But in a long footnote in *Black Skin, White Masks*, Frantz Fanon comments on the relationship between the mirror stage and race. The white subject, believing in their reflection, forgets about it. The Other, by contrast, looms into greater view, coming to be perceived, in Fanon's words, 'absolutely as the not-self – that is, the unidentifiable, the unassimilable'. The racialised subject can't help but internalise this perspective. You see your own body as 'unidentifiable' or 'unassimilable'. Stalled at the specular stage, you take the mirror's reflective membrane with you wherever you go. It becomes impossible to move beyond your own reflection.

Maybe my brother came into being in that moment of self-splitting in front of the mirror. He looked like me, but wasn't. He was the reflection I couldn't move beyond, the Other in me I was fascinated by as a child, and then spent my teenage years avoiding. He was unassimilable matter left over.

Recently I discovered I was wrong: I'd written about a brother years before. Visiting my parents, I found a blue exercise book filled with stories from primary school. I flicked through the pages, pausing at one story written when I was eight, called 'Murder or Murderer?', which begins with the protagonist, a young boy, going out to play in the garden. His mum calls after him, telling him to be nice to his brother. Outside, he sees a knife shining in the grass and a change comes over him:

> I thought, I thought for a long time then I remembered brother, I'll kill him, really, the knife erged [*sic*] me to kill him kill him now I walked slowly back to the house in determination.

Walking past his mum, he goes up to his brother's room and charges in. But before he can do anything he sees his brother lying there, already dead. The story ends by revealing it was all just a trick played by the brother who'd seen him in the garden and – presumably guessing what he was going to do – decided to fake his own murder.

The mania of the story's violence is unsettling, though not unusual. Carl Jung apparently asked his two-year-old daughter Agathli what she would do if a baby brother were to be born that night and she responded, 'I would kill him.' But there are strange things about 'Murder or Murderer?' beyond the fact – forgotten or suppressed – I'd created a fictional brother long ago.

Underneath its banal dreaminess, several details diverge from reality. My family never had a garden, and the interplay with the worried-but-absentminded mum (who manages to leave a sharp knife lying on the grass) feels false. My mum was tidy around the house and she worked near Holborn, so my dad – who worked from home – took me to school and picked me up. Both adjustments, like the addition of the brother, sketch out the sort of conventional family I must have subconsciously craved. But if I had any desire for that family I also, clearly, wanted to destroy it.

Perhaps, since I was eight when I wrote the story, I was embarrassed to still feel any yearning for a brother. It's notable that the knife is what 'erge[s]' the protagonist to kill; he's unable to admit the murderous rage as his own. Reading it now, the thing I find moving is the story's atmosphere of failure, captured in that moment of surprise – which is deeply unsurprising – when the brother's dead body is revealed. The speaker realises what he was about to do and the violence of his conviction drops away, replaced by a familiar sadness. It's impossible to kill what was never alive.

In late winter, 2021, I went for a walk with a friend in Downhills Park. The schools were open again. Trees made closed shapes at each other in the rain. We talked about siblings. My friend was a middle child and hated being alone. Part of him wished he'd grown

up as an only child. I told him my theory that only children don't like being alone, they like being alone around others.

He asked what the difference was. I said that only children evolve with an experience of loneliness that makes them think, why wait for company that might never arrive when you can reject the need for company altogether. They develop a kind of self-sufficiency they can carry around with them and lay out like a blanket, however loud the world gets. But they still want to be with people. That feeling never leaves.

Our conversation turned to writing. I said I hadn't been doing much. The only thing I'd been able to work on were these weird, small poems addressed to a fictional brother. I was unsure if they *were* writing. 'Where did they come from?' he asked. We drifted to either side of the path as a white dog ran ahead of us.

That conversation, though short, forced me to speak him aloud – my brother. At home, I put everything I'd written into a single document for the first time. The poems felt more substantial, but shameful. I felt the guilt I had in the past, about conjuring this being into life and then leaving him in limbo. He stared back at me: I and not-I. My confusion about the poems – where did they come from? – seemed to betray a deeper fraudulence; if I couldn't even explain them to myself, then maybe I was faking the emotion attached to the work.

There was something else about them, too. Those jagged fragments of text – hiding more than they showed, fixated on the language with which they addressed the Other – emanated loss. I worried, as a result, they'd strayed into morally dubious territory. What about the real family and friends who'd disappeared over the years? Why had I turned away from them to mourn someone who never existed?

One day, talking about this to another friend, she stopped me and asked, 'But why *can't* you mourn family that never existed?'

I hadn't put it to myself like that, but it made sense. Things started to move inside my head. I thought about the perversity of mourning, its asynchrony. I'd always remembered the death of my grandma with spotlit clarity. I was thirteen, and my mum told me as soon as I came

through the front door with a bag of McDonald's. I cried immediately. A glut of feeling. It was a moment of fully intuitive grief. Other times since then, it's been murkier; I've questioned whether I was mourning someone without realising it or still waiting for the mourning to begin.

But another feature of mourning is that it doesn't require an object, let alone one that exists. You can mourn what never happened, or what you thought would happen. Mourning can take as many forms as absence itself.

I grew up with a particular absence, living in London but aware of a parallel world – Indonesia, the country of my mum's birth – where I had a huge, interconnected family. At one stage, my mum thought about raising me in Jakarta alongside my aunts and cousins. We travelled over there a lot. But in the late nineties riots spread through the country and Chinese Indonesians were attacked on the streets. She decided it was too dangerous, so we stayed in the UK where the circle of my family was mostly confined to me and my parents. My Indonesian family was still there, geographically distant but bound up in my experience of the world. I mourned them like a brother. I could almost touch the space in my life they didn't occupy.

One of the main arguments of Mitchell's *Siblings* is that psychoanalysis has historically privileged the vertical over the lateral axis. The vertical axis focuses on descent – relationships between parents and children – whereas the lateral axis is more concerned with alliance, with sibling relations and other forms of kinship. Mitchell's long-standing critique of psychoanalysis has centred on its patriarchal bias, how it's drawn continually to the figure of the father. Part of this can be seen in the obsession with descent. How can you understand the way a 'specular *I*' becomes – or fails to become – a 'social *I*' without looking at lateral relationships?

Vertical narratives can be crushing over time. I think of the trail of dead fathers on my mum's side, the trauma descending from grandmother to mother and mother to child with inevitable, accruing force – personal agency, by the same movement, fading away. My

mum grew up in Pekanbaru, a city in Sumatra. Her grandfather died while delivering cargo during the Second World War, mistakenly poisoned by the Japanese Army. Her father died from colon cancer when she was eighteen. She left school early and joined a brother in London where she enrolled in a secretarial course and learnt to speak English. The death of her father became linked with migration, a rupture in the language.

I spent years shirking the weight of descent and then, in my early twenties, began to experience a range of new symptoms: a fear of flying and motorways, of leaving London, of crossing bridges. If I wanted to get from Embankment to the Southbank I now had to walk slowly, palms sweating, down the centre of the pedestrian bridge, ignoring the sludge of brown water either side of me.

When I told friends about this, there was something hilariously neat and metaphorical about the whole situation. It felt like I was describing a character from a novel – scared of bridges, of the gap between cultures, who'd taken on his mum's unspoken shame around leaving home. I couldn't bring myself to cross any border, however small, without being overcome by the fear I would be shut out forever, unable to return. But that was how it felt, and no amount of interpretation or ridicule could make it disappear.

The brother poems began in this place, hemmed in by fear, which must explain why I didn't want to name my brother or describe his appearance. What use did I have for a fleshed-out person? I wanted to address the gap. It was the gap my mum had crossed in coming to London; it was the same gap I now felt between here and anywhere else. But in writing poems to my brother, a change occurred. I could let myself feel – beyond embarrassment – the vertical pressure of descent and trauma, the grief that had been absent and present throughout my childhood.

Mourning, according to Freud, is the process by which the lost object becomes an internal image. Mitchell refers to the hysteria or 'haunting' that can ensue if this doesn't happen, when the object 'persists as though it has not been lost, but is everlastingly

present'. What happens when a migrant loses their home without fully mourning it? My mum didn't put many pictures up around the house, maybe because Indonesia was still, if anything, too present. I grew up haunted by elsewhere. And as a lonely teenager I turned to poetry, one of the characteristic features of which, like song, is its way of talking to someone ('you', 'he', 'they') as if they were right there. No response is necessary; language makes them present.

'It is only when you are stranded in a hostile country that you need a romance of origins,' writes Saidiya Hartman. But perhaps that romance doesn't have to involve looking upwards and to the past. There's also the romance of what's next to you. When I write to my brother I feel the vertical pressure ease. We're carrying the burden of grief together. And that sideways gesture of calling out, of talking into the unknown, changes my relationship to myself. I'm no longer stranded. That act of talking – saying 'you' – brings us nearer. It draws my family, real and imagined, onto the same plane as me. I speak into the silence and something fills the gap. ∎

Will Harris

Brother Poem

My collection of stones
kept carefully wrapped
in a Clarks shoebox
under the stairs a dozen
different coloured gems
pink green lilac all
mine not yours but I
let you hold them even
my favourite rose quartz
which you said you'd
seen before me though
only after you lost it

You came to me as three
white lakes each whiter
than the other this is how
my mind goes when
 I look at the sky
 I call the captain
tall my face and lie down
by the water brother
 you know I know
 nothing

One day we saw a man singing
outside his front door

 No said Mum
he doesn't live there that's where
his mum lived when she was alive
that's why he's singing there

 Every poem is another
 poem that didn't make it

 that in trying to write
 the liquid crystal of my
 eye shut out

 behind whose silence
 crackles the poem
 I could be writing

 which in writing takes
 the place of you

I liked the mist
but we agreed it
was a bad day
for a beach trip
all the windows
rolled down low
small droplets
of ice in her eyes

Our snapped-off shadows
made a simple shape
one within the other like
a folded napkin and you
talked to me in your real

voice I wanted to make
the dust just no I couldn't
couldn't see us all there
eating instant noodles
sitting in front of the tv

You said cemeteries were like
 funfairs without the candyfloss

Some days I'd go there to watch
 the milk plume in my tea

When the sun shone my tummy
 rumbled

 I was searching for
your name among the tombs

On the wrong side of the glass
 the doors slid shut
and off you went
 I never cried
 but that day
my round face white with fear
 mirrored yours
you ran back to find me
 sitting on the shoulders
of a tall white man

and I cried at the sight

Brother it was last week but
I'm five
 we read the sky for
signals rose quartz means rain
at night but never avoiding
 rough seas we yes *we*
lead ourselves to the jetty
hand in hand empty as a weeto
boats like rabid ski dogs
 shhhhhh we can't be out
this late
 but you yes you
are setting sail by this point
 only you

 He looked down with such
 sadness he couldn't bring
 himself to call out to a
 member of the crew it was
 too overwhelming to be
 helped and too simple

 to bear it was the thought
 that finally struck him as
 he looked up at the captain
 and with great sadness
 looked back at his brother
 still unable to see it

Give the gift of Membership

Set someone special on a journey through human history with 12 months of extraordinary exhibitions and events at the British Museum.

The British Museum

Buy now

Ways to buy
britishmuseum.org/membership
+44 (0)20 7323 8195

Large vase, tin-glazed earthenware (maiolica), from the workshop of Orazio Fontana, made in Urbino, Italy, about 1565–1571, with gilt-metal mounts made in Paris, France, about 1765. Part of the Waddesdon Bequest.

H, 2018
Courtesy of the author

THE ERL-KING

Emma Cline

We were taking our nephew on a walk, H and I: buckling the baby into the stroller, finding his giraffe toy and tucking his blanket around his legs. He was a happy baby, startlingly so: I had heard him cry, really cry, only once.

'It's weird, isn't it?' H said. 'How mellow he is.'

He was our younger sister's baby – her and her husband's baby, I guess. They were young parents and excessively chill. It seemed better that way – to be young enough that your self-conception hadn't yet solidified, that there wasn't some well-grooved lifestyle now under threat from the demands of parenthood.

'Does he need socks?' I asked. 'Another jacket?'

'The blanket is fine,' our sister had said, barely looking over to H and me. 'Don't worry.'

The baby let his arms be guided, one by one, through the stroller's harness. He blinked a few times, squinting at H as she pulled his beanie down his nearly translucent forehead. He was a Pixar baby, an angel emoji baby – his skin was rosy, immaculate.

My own skin was almost back to normal: in a panic over a particularly bad run of jawline acne, I'd ordered a benzoyl peroxide wash off Amazon. I used it once, and it seemed to work. Heartened, I used it again the next morning. Almost instantly, my skin went

mottled pink, a peachy cast appearing on my eyelids and my face puffing out so I looked like I was wearing a mask. I took a series of photos in the full sunlight of my front window and sent them to H. The pictures were disgusting, bizarre.

'Stop touching it,' H said. I hadn't even noticed my hand was on my face. 'It really doesn't even look that bad.'

'It's pretty bad.'

She shrugged. I couldn't tell if she was annoyed with me, if it was annoying for me to complain about something so stupid. The rash was already fading.

'Is he warm enough?' I said.

'I think yeah, with the blanket.'

W e'd both taken H's edibles, currant-flavored gummies from a tin, a label that made them look like a grandmother's pastilles. Mine was starting to hit, a pleasant pulse in the chest. Leaves on the trees and on the ground looked very specific. I'd only had five milligrams, but H was up to ten. Her tolerance was high these days; anything less barely made a dent in the nausea. It helps with social stuff too, she'd told me. Made things easier. Being around the family, sitting through dinners.

I was only visiting for the weekend; she lived here all the time now. The same town where we'd grown up.

I zipped up my coat, a puffa jacket I'd grabbed from our parents' closet. It was my coat from college: back then, I'd painstakingly used a Sharpie to color in the logo so THE NORTH FACE had just become NO, some vague, lame protest against brand names, 'capitalism'. The Sharpie had entirely faded: THE NORTH FACE had returned.

There was a water bottle in the stroller pocket and the jangle of our sister's car keys.

'Wait,' H said, 'they might need the keys.'

H ran back inside with the keys and came out with another water bottle. Her face was pale, her baseball cap down around her eyes.

With the cap on, she looked normal. A young woman like any other.
'Ready?'

T he bike path was only a few blocks from our parents' house. H
pushed the stroller first, bumping along the sidewalk, crossing
the creek. It was nearly dry, the rocky bottom exposed, the winter
blackberry bushes growing by the barest trickle of water.

When we were kids, I'd found a copy of *Penthouse* down in the
creek bed. H and I gathered around to goggle at the waterlogged
pages before we were suddenly and simultaneously overcome with
wordless horror, flinging the magazine down from where it came.
I almost brought it up, but I knew without looking at H that she
would be thinking of it, too, one of the many stories we repeated, the
landmarks in our shared history – and there wasn't anything new to
say about it. We were born sixteen months apart: sometimes it felt like
we had almost the same brain.

At the intersection, a pickup started to inch forward, then stopped
halfway.

H gestured at the driver to go; he didn't move, and we hustled to
cross, feeling exposed and harried, the stroller tilting up the curb.

We passed the Christian Science building on the corner, the empty
lot lush with winter green. Then my fifth-grade teacher's house. The
citrus trees along their fence were so bright and heavy with fruit that
the sight was psychedelic.

'Do you want me to push?' I said.

'Not yet.'

When I rubbed along my jaw, a little skin flaked off. 'Gross.'

'Stop.'

I looked over to see what was happening in her face. Her smile was
mild but her eyes were on the road.

'I'll push now, okay?'

The stroller was a little unwieldy. Pushing it made me nervous, aware of everything that might go wrong. When we finally got to the bike path, a cyclist passed us at a good clip: I tensed up, adjusting my grip on the stroller handles.

The silences between H and me were a half second too long – or were they? Maybe not. At least the bike path was mostly empty: a few older people out on walks, giving us abbreviated nods.

There were more blackberry bushes, a bare persimmon, a few buckeyes and a small pine tree that still had Christmas ornaments – in December, people decorated it with photos of their family pets. This kind of thing had often seemed silly to me, but lately it was easy to be moved by any display of sentiment or kindness or humanity, my eyes welling instantly. I only wanted softness. *Thank you so much!* I signed all my emails, then. *I so appreciate your help,* I was always saying, and I truly did. I was nakedly grateful, prostrating myself with earnestness, absolute desperate gratitude. I emailed doctors and authors of PubMed articles and a very kind Pulitzer Prize-winning memoirist who had written a book about the same cancer subtype – a Pulitzer Prize winner! Surely God would note the prestige and reward H in the form of a good outcome.

The message boards and frantic research, my harassment of the Department of Managed Health Care, the calling in of all the favors I was owed – did H want me to do any of those things?

No.

I hate you, she said. A few times, when she said this, she actually meant it. You need to stop, she said.

I did stop, at some point. Not soon enough, but I did stop.

The stroller bumbled along the bike path.

'He's so quiet in there,' I said.

'He's probably asleep. I think he likes the cold air.'

Without saying it out loud, both of us seemed to agree that we would not actually check to see if the baby was asleep.

'Who's taking you next week?' I said.

'Mom, probably. I could just drive myself. It's really not bad.'

'No. It's good to have someone with you.'

'Yeah,' H said. 'I don't know.'

H seemed to pause longer before she said things these days, like even her thoughts had become more private – she had gone to a place where we could not follow. If anything, she had gotten more composed, more contained. Even that first day, she hadn't cried. I'd been home, hundreds of miles away. She'd texted me, my phone going bright on the porch table and I picked it up and I couldn't believe it either.

WTF she texted, then a crying-laughing emoji.

The sun was so bright, that day, it was so lovely. Earlier, I had gone to the beach with Alex. Though it was October, the days were still warm, and I'd read a book on my towel about female painters in the fifties, drank the Trader Joe's seltzer and picked at a bag of green grapes we'd brought. Alex ate supermarket sushi with his fingers. I'd been vaguely depressed about an old boyfriend. I spoke at length about feeling thwarted, like I would never feel at home in the world. Though probably I enjoyed the drama. The window unit had broken, my shower had stopped working. The bad things in my life seemed bad enough, and occupied me fully, but reading my sister's texts on the porch, all at once I understood that I had entered a new kind of bad, and that I would miss the time when I had only worried about my apartment, my romantic failings, my bad skin. I missed it terribly.

But this was months later. Things had settled, in their way. Become manageable.

Both of us were in leggings and work boots. My old puffa jacket, H in a Hanes sweatshirt and Oakland A's cap – the cast-offs scrounged up from my parents' house.

'Do you want me to push the stroller now?'

'No,' I said. 'I'll tell you if I do.'

We passed the brown house on the big lot at the top of the hill –

their mailbox was a miniature of the house. The yard extended into a grove of trees.

'I wonder if there's a pool back there.'

'I think I went to a party there,' H said. 'In high school. I can't remember if there's a pool though.'

'Whose house was it?'

'Maren Dover.'

'Oh yeah. Didn't she get married?'

'Yeah, I felt bad cause the wedding looked really small. Like they should have just waited till things were back to normal and they could have had a real one.'

The stroller bumped along.

'Wasn't she the one who tried to lick your shoe?'

'No, God. That was Sam. Her mom was the vet.'

'Right. And she'd pretend to be a dog at recess. Freaky.'

'Very.'

H veered toward one of the recycling bins out on the curb, the blue the same electric color as her sweatshirt. She dropped in her empty water bottle and let the lid slam.

'I'm trying to drink a lot of water,' she said. 'I guess it's supposed to help, especially like the first few days after.'

'That's good.'

I felt like I should say something more, but I couldn't think of anything.

'He's definitely asleep,' she said.

I kept pushing the stroller.

When I got stoned, I was sometimes helpless to stop myself from saying something that would make the anxiety worse. Like the time I was driving with an ex in the desert and we were running low on gas and I suddenly said in a strange, faraway voice that we would run out of gas and we would be stranded and that a murderer would come across us, there by the side of the road. As I spoke it seemed more and more true, a spell I was casting. I couldn't take it back.

'What if,' I said, 'we got back to the house and the stroller was empty?'

I didn't want to say it, but I had to. I regretted it instantly.

'Oh God.' My eyes were big. 'Fuck.'

'Why did you even think of that?'

'Like, how awful. We get home and he's gone, totally disappeared. What would we even do?' My stomach dropped.

H was laughing, like it was dumb. I was queasy. Why had I said it? I was certain that if we stopped and peered into the stroller, it would be empty. It was nauseating. I had called this into being, this horrible thing, by saying it out loud. Even though she'd tried to laugh, I could tell H was feeling it too – why did it have this hold over both of us?

'I wish you hadn't said that,' she said.

'Sorry. Me either.'

'Ugh.'

Still. Neither of us slowed down – we kept walking, and I kept pushing the stroller along in front of us.

'Should we check?' H said. Her voice was getting just a little frantic.

'If he's in there?'

'I actually feel sick. God. Sorry. It's fine.'

'We just freaked ourselves out, that's all,' I said. 'It's fine.'

She adjusted her cap. 'I hate you.'

'Do you remember that thing we had in the Matheson house. Like a plastic record player?' I said. 'And there was this story on one of the records, like a fairy tale or something, this father riding a horse with his son and his son is really sick. And he's riding really fast through the woods, and maybe even being like chased?'

H didn't say anything.

'It was blue?' I said. 'Maybe like a Disney record player or something?'

'Not really,' she said.

'It really scared me. But I was obsessed, too, like listening to it over and over. This one part, this one story. And when the dad finally gets to where he's going, his son is dead.'

'Ugh.'

'Yeah, it was really weird.'

H had stopped abruptly in the bike path, her face glitching, and I thought maybe she had remembered the record after all. That maybe it had scared her too, as a child; more proof of how we were so similar, our brains the same brain. Or maybe what scared her was the invocation of death.

But then I saw that H had stopped because a man was lumbering toward us on the path; a tall man, dressed in dark pants and a dark jacket. His gait was outsized, his movements frantic.

He veered closer, aimed specifically for us.

'Hi,' I said, reflexively.

My sister tensed up beside me. We were both frozen.

'Oh,' the man said. 'Oh well.' He was our age, but something wasn't quite right.

I almost said, 'How are you?' But I didn't. His features were blurry somehow, his energy prickly.

'You have a baby now?' He seemed to be directing this question to H She was stone-faced, her eyes opened a little too wide. She didn't say anything. I could not figure out what was happening – I thought, for a brief instant, that the man would grab the baby. Another danger, another threat. What were we supposed to do? I was thrumming with anxiety. Another half second passed, the man already starting to lurch away, and then I recognized him: it was David Valentine. H's high-school boyfriend. My mouth was open. H was looking at me, her eyebrows raised. We both watched him walk away, lumbering up the hill we'd just descended.

'Fuck,' I said, under my breath.

We held eye contact, H and I. We started to walk again, pushing the stroller. I turned back to make sure he wasn't following us.

'Are you fucking kidding me?' I said. 'I literally did not recognize him.'

'But you sounded so nice,' she said.

'When I said hi? I think I thought it was just, I don't know. A stranger.'

We both kept turning around though he was out of sight.

'He really doesn't look very good.'

'I think he's not doing well,' she said. 'Like not totally there. It's sad.'

'What the fuck,' I said. 'Fuck.' I shook myself, pushed the stroller more swiftly. I had been so afraid. We had both been afraid. It was just David Valentine. There were problems, there was darkness, but it was not ours.

Some spell had broken.

I stopped the stroller and went around to the front: there was the baby, tucked under his blanket, his cheeks flushed and his eyes closed. He was fine, he was asleep. I touched his neck, worried he might be chilly. If anything, he was too warm.

H took over pushing the stroller. We were both a little breathless.

'God, I was like, is this it?' I said. 'When he got up so close.'

She let out a quick laugh that stopped abruptly. Then she was laughing harder. I was laughing too.

'Fuck,' she said. 'God.'

We picked up the pace, breathing in the cold air. H navigated the stroller around the cracks in the sidewalk. We weren't so far from home, my sister and I. It would be dinner time when we got back. The baby would get his evening bath in the sink. He would be wrapped in a towel by his mother. The dogs would be fed outside, each from its own metal bowl.

The future, whatever it was, whatever it contained, wasn't happening, not yet.

We turned onto our parents' block.

'I was really scared,' H said.

'Me too,' I said. We both looked straight ahead. 'But it was funny, too. Wasn't it sort of funny?' ■

CONTRIBUTORS

Colin Barrett is from County Mayo, Ireland. In 2014, his debut collection of stories, *Young Skins*, was awarded the Rooney Prize, the Frank O'Connor International Short Story Prize and the *Guardian* First Book Award. His stories have appeared in the *Stinging Fly*, the *New Statesman*, the *New Yorker* and *Harper's*. His second short story collection, *Homesickness*, was published in 2022.

Sara Baume is the author of three novels, *Spill Simmer Falter Wither*, *A Line Made by Walking* and *Seven Steeples*, and one book of non-fiction, *handiwork*. She lives and works on the south coast of Ireland.

Suzanne Brøgger was born in Copenhagen in 1944. She is the author of more than thirty works of fiction, essays, poetry and memoir, including *The Jade Cat* and the autobiographical trilogy of liberation, experimentation and identity, *Crème Fraîche*, *Yes* and *Transparency*. She has been a member of the Danish Academy since 1997.

Sebastián Bruno is an Argentine photographer, film-maker and educator based in South Wales.

Emma Cline is the author of the novel *The Girls* and the story collection *Daddy*. She was named one of *Granta*'s Best Young American Novelists in 2017. Her next novel, *The Guest*, is forthcoming in 2023.

Omer Friedlander is the author of the short story collection *The Man Who Sold Air in the Holy Land*. He has an MFA from Boston University, where he was supported by the Saul Bellow Fellowship, and is now a Starworks Fellow in Fiction at New York University. His stories have won multiple awards, and his writing has been supported by the Bread Loaf Work-Study Scholarship and Vermont Studio Center Fellowship.

Charlie Gilmour's writing has appeared in the *Guardian*, the *Observer*, the *Sunday Times*, *VICE* and *Vogue*. His memoir, *Featherhood*, was shortlisted for the 2021 Wainwright Prize and has been translated into several languages.

Lauren Groff is the author of six books of fiction, most recently the novel *Matrix*.

Will Harris is a writer based in London. His poetry collection *Brother Poem* is forthcoming from Granta Books in the UK and Wesleyan University Press in the US in 2023.

Alice Hattrick is the author of the non-fiction book *Ill Feelings*. Their work has been published by *TANK*, *frieze* and *ArtReview*, and was included in *Health*, part of the Whitechapel Gallery's series Documents of Contemporary Art.

Lauren John Joseph is a writer, film-maker and artist educated at King's College London, University of California, Berkeley and Central St Martins. They are the author of the experimental prose volume *Everything Must Go*, and the plays *Boy in a Dress* and *A Generous Lover*. Their novel *At Certain Points We Touch* was selected as one of the *Observer*'s Top 10 Debuts of 2022.

Lee Lai is a cartoonist and graphic novelist from Melbourne, Australia, currently living in Montreal, Canada. In 2021, she was chosen as one of the National Book Foundation's 5 Under 35 for her debut graphic novel, *Stone Fruit*.

Viktoria Lloyd-Barlow left school without any qualifications. When her youngest children started school she began studying too, and earned first-class undergraduate and postgraduate degrees followed by a PhD. Her first book, *All the Little Bird-Hearts*, will be published in 2023 and she is currently writing her second novel.

Sophie Mackintosh was born in South Wales in 1988, and is currently based in London. She is the author of the novels *The Water Cure* and *Blue Ticket*. Her work has been published by the *New York Times*, the *Stinging Fly* and others. *The Water Cure* was longlisted for the 2018 Man Booker Prize. Her next novel, *Cursed Bread*, is forthcoming in 2023.

Jamal Mahjoub was born in London and has lived in Sudan, Denmark, Spain and the Netherlands. He has published literary fiction and non-fiction, as well as crime fiction under the pseudonym Parker Bilal. His writing has won prizes including the *Guardian* African Short Story Prize, the Mario Vargas Llosa NH Hotels Short Story Award and the Prix de L'Astrolabe. His latest novels are *The Fugitives* and *The Trenches*.

Andrew Miller is the author of nine novels, including *Ingenious Pain* and *The Slowworm's Song*. He lives in south Somerset.

John Niven is a Scottish author and screenwriter. His books include *Kill Your Friends*, which was longlisted for the Desmond Elliot Prize, as well as *The Amateurs*, *The Second Coming*, *Cold Hands* and, most recently, *The F*ck-It List*. 'O Brother' is an extract from his memoir of the same title forthcoming from Canongate in September 2023.

Vanessa Onwuemezi is a writer and poet living in London. She won the *White Review* Short Story Prize in 2019 and her work has appeared in *frieze* and *Prototype*. Her debut story collection, *Dark Neighbourhood*, was published in 2021 and was named one of the *Guardian*'s Best Books of 2021. It was shortlisted for both the Republic of Consciousness Prize and the Edge Hill Prize in 2022.

K Patrick is a writer based in Glasgow. In 2021 they were shortlisted for the *White Review* Poetry Prize and Short Story Prize, and in 2020 they were a runner-up in the Ivan Juritz Prize and the Laura Kinsella Fellowship. Their debut novel, *Mrs S*, will be published in summer 2023.

Ben Pester's debut short story collection *Am I in the Right Place?* was published in 2021 and was longlisted for the 2022 Edge Hill Prize. His work has appeared in the *London Magazine*, *INQUE*, *Hotel*, *Five Dials* and elsewhere. When not writing fiction, he is a technical writer, and lives with his family in north London.

Karolina Ramqvist is a Swedish author living in Stockholm. Her books include the novels *The Beginning*, *The White City*, which was awarded the P.O. Enquist Literary Prize, and *The Bear Woman*, which is her most recent book to be translated into English.

Taiye Selasi was born in London. She holds a BA from Yale and an MPhil from Oxford. Her short fiction was selected for *The Best American Short Stories 2012* and she was named as one of *Granta*'s Best Young British Novelists in 2013. Her debut novel, *Ghana Must Go*, was published in 2013.

Natalie Shapero is the author of the poetry collection *Popular Longing*.

Julian Slagman is a German photographer currently living between Hamburg and Gothenburg. In 2021 he received the Aenne Biermann Prize for Contemporary German Photography for his work 'Looking at My Brother'.

Angelique Stevens lives in upstate New York where she teaches creative writing, literature of genocide, and race literatures. Her non-fiction has been published or is forthcoming in the *New England Review*, *LitHub* and *Best American Essays*. She holds an MFA from Bennington College and an MA from SUNY Brockport.

Saskia Vogel is the author of *Permission* and a translator from the Swedish. Karolina Ramqvist's *The White City* and *The Bear Woman* can both be found in her English translation. Vogel's work can also be read in the *New Yorker*, *LitHub*, *Guernica*, the *White Review*, the *Offing* and elsewhere.

Caroline Waight is a translator working from Danish, German and Norwegian. She has translated a wide range of fiction and non-fiction, most recently, *The Lobster's Shell* by Caroline Albertine Minor, *Island* by Siri Ranva Hjelm Jacobsen and *The Chief Witness* by Sayragul Sauytbay and Alexandra Cavelius.